Library of Congress Cataloging-in-Publication Data available.

ISBN 978-1-4521-7686-4

Manufactured in China.

Chronicle Books LLC
680 Second Street
San Francisco, CA 94107
www.chroniclebooks.com

10 9 8 7 6 5 4 3 2 1

Chronicle Books publishes distinctive books and gifts. From award-winning
children's titles, bestselling cookbooks, and eclectic pop culture to acclaimed works of
art and design, stationery, and journals, we craft publishing that's instantly
recognizable for its spirit and creativity. Enjoy our publishing and become part of our
community at www.chroniclebooks.com.

— Thanks —

To Helen Conford and Cecilia Stein, editors extraordinaire.

To Karolina Sutton, Adam Roberts, and the team at Particular Books.

To my dear family and friends, sorely neglected while I've had
my head buried in research, writing, and drawing.

To the mountain of uncredited photographers whose work
I studied online to understand just exactly what olms, and so many
of the other creatures in my book, actually look like.

And to Paul, for your patience and support and
for keeping me fed and watered while I made this book,
without whom I myself might well have perished.

Finally, to all the animals that have enriched my life
and piqued my curiosity: the howler monkeys of Nicaragua,
kangaroos of the Nullarbor, albatrosses of Dunedin, caiman of Ometempe,
tree snakes of Taman Negara, red kites of mid-Wales,
birdwing butterflies of Sri Lanka, turtles of Ningaloo Reef,
the seabirds of home, and so many more.

A Wild Child's Guide to
ENDANGERED ANIMALS

MILLIE MAROTTA

CHRONICLE BOOKS
SAN FRANCISCO

As a child, I was obsessed with animals of every kind. Big, small, feathered or furry, those that swim, walk, fly, or slither, I wanted to learn about them all. I am just as in love with the natural world today as I was back then. But in my lifetime, much has changed for the animal kingdom. Today we are losing species more quickly than we are discovering new ones.

The International Union for Conservation of Nature (IUCN) Red List tells us how well different species from all over the world are surviving and assesses their extinction risks. So far nearly 97,000 species have been assessed, but, sadly, more than a quarter of these are threatened with extinction. While we know the plight of the mighty elephant, charming giant panda, charismatic chimpanzee, and magnificent polar bear, what of the other vanishing species whose stories are not often told? Mysterious baby dragons of the underworld, the dodo's long-lost cousin, gargantuan lobsters, and incredible shrinking reindeer—they too need our help and our attention.

Choosing which animals to include was a difficult task. I began with the IUCN Red List and then found out more about some of those animals from *National Geographic*, the World Wildlife Fund, and

other online resources. Each animal story featured in these pages is unique—we have insect imposters, recycling beetles, birds that sleep in mid-air, desert-dwelling fish, and walking pine cones—and each one tells of the brilliance of the animal kingdom and how much we are losing from our vibrant world when another species is lost forever. In the end I chose a varied collection of birds, invertebrates, fish, mammals, reptiles, and amphibians from different habitats across the globe.

As you weave your way from the oceans to the forests, from mountaintops to the Arctic tundra, you'll discover a collection of endangered animals that call these places home. At the end of the book I've given some ideas of what you can do next if you want to help them survive and thrive.

My hope is that you will fall in love with these creatures just as I have, and that celebrating these beautiful beasts, who are quite literally hanging on for dear life, will help to inspire the next generation of conservationists, naturalists, biologists, zoologists, volunteers, and nature lovers. There is no truer wonder than that of our animal kingdom, and every species deserves its place in our world.

Millie Marotta

— Oceans —

Our salty seas make up more than 70 percent of the Earth's surface: The five major oceans—Atlantic, Pacific, Indian, Southern, and Arctic—are, together, the largest habitat on the planet. Oceans are where life on Earth first began, and they continue to support the greatest diversity of life. From the coral reefs of the warm tropics to deep ocean trenches, icy polar regions to shallow seagrass beds, a kaleidoscope of creatures flourishes in their many habitats.

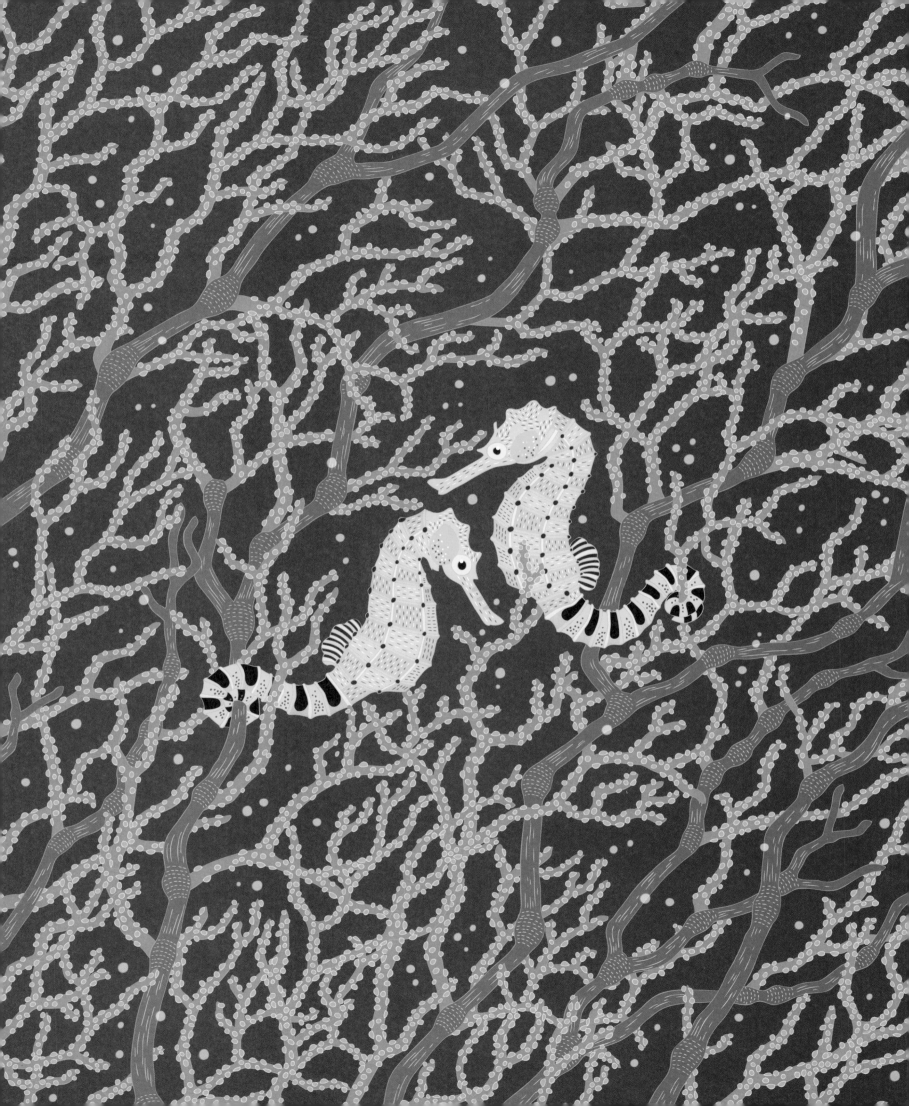

Tiger Tail Seahorse

Seahorses are one of only three animals (with pipefish and leafy seadragons) where it's the male that gets pregnant. Many species of seahorse remain faithful to their mates throughout the breeding season, greeting each other each day in a courtship dance. Other pairs remain monogamous their entire lives, among them the tiger tail seahorse, so named for its distinctive stripy tail.

When breeding, the female deposits her eggs into the male's brood pouch, found toward the bottom of his belly. He fertilizes them in his pouch, then keeps them there, safe and nourished, as they develop. After two to three weeks, hundreds of miniature, perfectly formed tiger tail seahorses burst out into the water. The babies, only 1 cm long, are immediately independent of their parents and drift away, at the mercy of the ocean currents.

Seahorses are rather inept at swimming, so when it comes to hunting they rely on stealth and disguise. Anchoring themselves to a piece of coral, and changing color to camouflage themselves from both predators and prey, they wait, toothless snout at the ready, to hoover up tasty brine shrimp as they drift by.

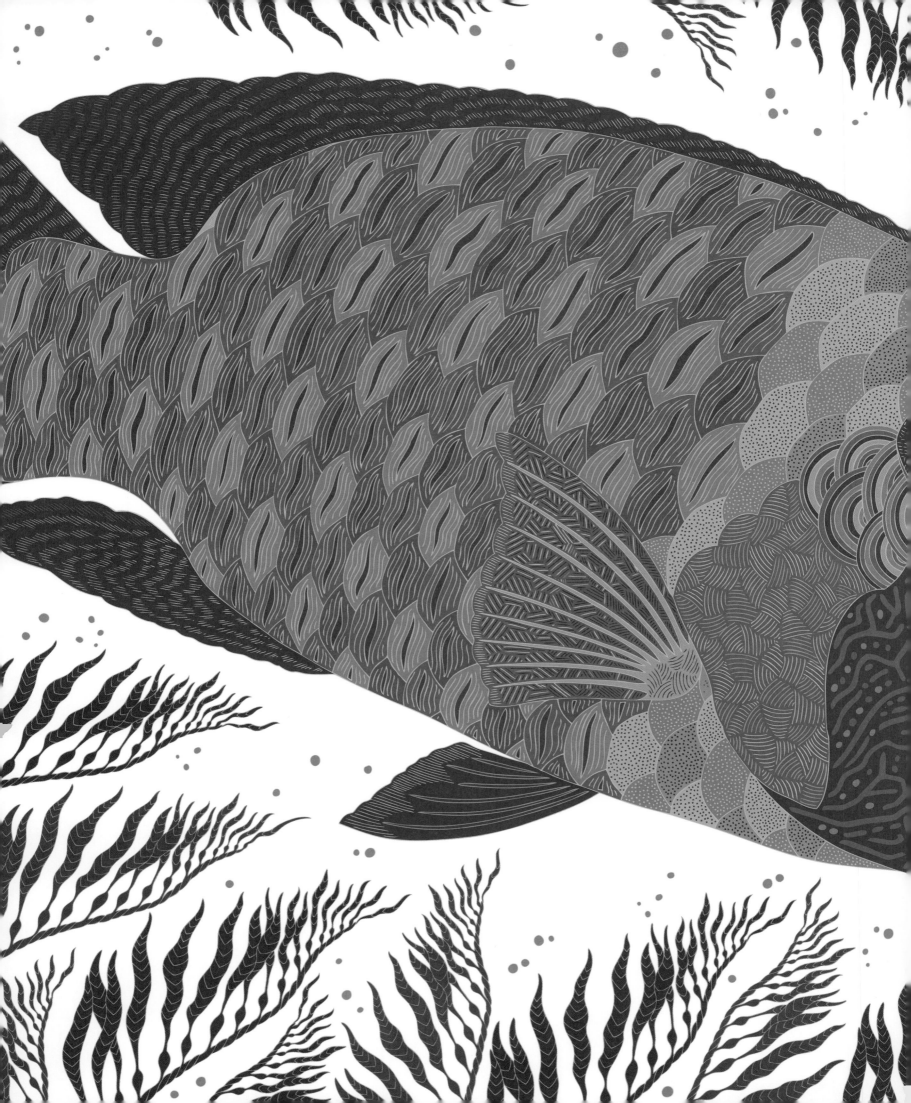

Humphead Wrasse

Among the coral reefs of the Red Sea, a young female humphead wrasse leaves her deep-water cave to feed. She hoovers up vast quantities of mollusks, crabs, lobsters, sea cucumbers—you name it—but she is also one of a few species that will tuck into the toxic crown-of-thorns starfish. This starfish eats growing corals, so in eating them the humphead wrasse is preserving her own habitat, which is already damaged by fishing methods involving dynamite and cyanide. As she hunts, she must keep an eye out for poachers: As one of the most expensive fish in Southeast Asia, she is vulnerable.

At about seven years old, she is almost ready to mate. By nine she has grown bigger than most females her age, and as she keeps growing her skin changes color, from rusty red orange to a vibrant greenish blue, and she loses her ovaries and develops testes. Incredibly, she changes sex and becomes the dominant male—known as a super male. He is a giant among his species—up to 6 ft long and a colossal 400 lbs in weight. That's more than two average-sized men. Only the very largest of females have a chance to become super-males and mate—and they will stay male forever.

European Eel

For eons, the Sargasso Sea, in the midst of the north Atlantic Ocean, kept its secret. European eel larvae hatch there, then embark on a journey that can last decades. Leaf-shaped and transparent, just a centimeter or so long, they drift on ocean currents for three years, across 3,400 miles, to the European coast. There they gather in estuaries and transform into miniature adults, or elvers. Males often linger, while females swim upstream to find homes in rivers and lakes across Europe, from Norway to Egypt, where they might remain for up to twenty years, growing up to 4 ft long— until one moonless, stormy night in autumn, when they feel an overwhelming urge to return to their birthplace. Back in the depths of the Sargasso, they will spawn, and eventually die.

People always knew that eels lived in fresh water but could never find any eggs or observe the eels breeding. Outrageous stories were told of the eel's mysterious beginnings—that baby eels were born from the gills of other fish or sprang from horse hairs dropped into rivers— until at last, in 1914, Johannes Schmidt, a Danish marine scientist, made the exciting discovery of larvae in the Sargasso Sea.

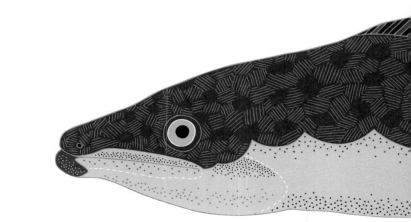

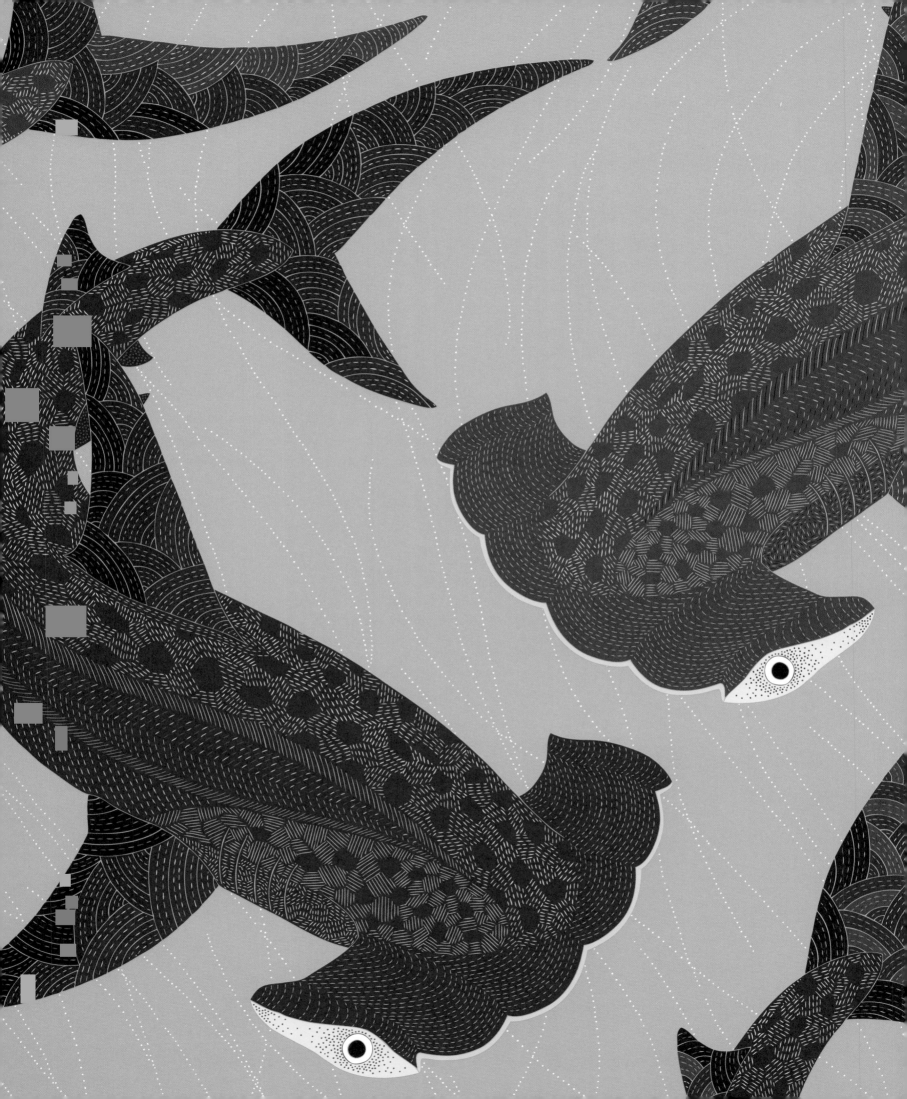

Scalloped Hammerhead Shark

Evolution often results in strange-looking beasts. Take the scalloped hammerhead shark. Its mallet-shaped head means it's a superior swimmer, and lightning-fast turns make hunting a cinch. Wide-set eyes provide excellent binocular vision and a vertical 360-degree view (although there's a blind spot right in front of its nose). Its nostrils are so far apart the shark can tell which one is catching the scent of dinner, and its incredibly small mouth (for a shark), with inward-pointing teeth, is perfect for snatching slippery fish and gulping them down.

No one knows why, but these giant fish gather together in the same waters time after time, forming huge schools, several hundred strong. But this predictable behavior makes them vulnerable as greedy fisheries know exactly where to find them. Others are caught by accident, in nets intended for other fish. Once tangled, a shark cannot swim, and this makes breathing difficult—as they breathe by swimming with their mouths open, absorbing oxygen from the water as it passes over their gills—and the problem is made worse by their unusually small mouths.

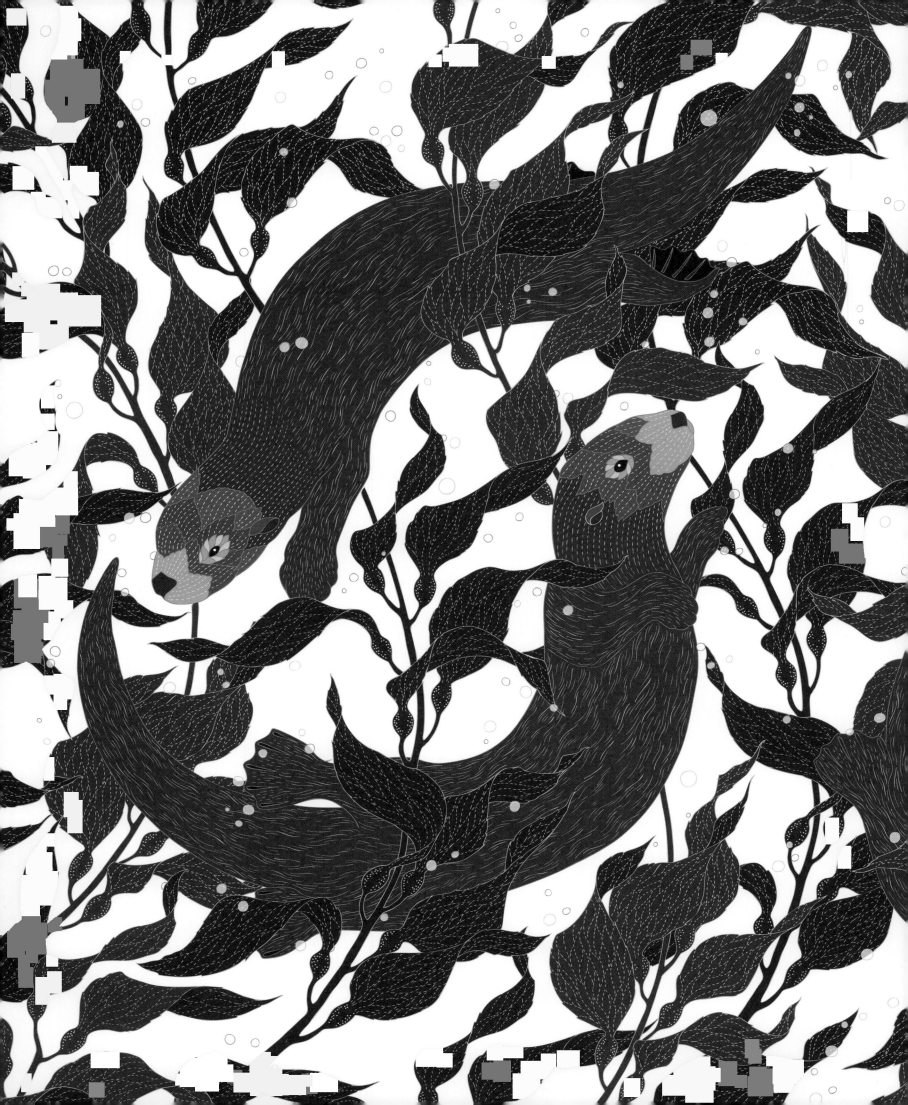

Sea Otter

In the Aleutian Islands, between the northern Pacific Ocean and the Bering Sea, water temperatures can drop to 32°F, so insulation is everything. Unlike whales and seals, the sea otter does not have a thick layer of blubber: Instead, it relies on its ultra-dense coat. It has the densest fur of any animal, ranging from 250,000 to 1 million hairs per square inch—a human has only about 100,000 hairs on their head.

The otter has to eat lots to stay warm—up to a quarter of its body weight every day—diving for mussels, sea snails, crabs, and clams, and it's one of the few mammals known to use tools: stones scrabbled from the seabed to crack open hard shells. But it is the sea otter's taste for sea urchins that makes it a keystone species.

Keystone species play a crucial role in the ecosystem—if the sea otter disappeared, the entire ecosystem would be affected. Sea urchins devour kelp forests, which absorb carbon dioxide from seawater, keeping the habitat healthy. Sea otters find these spiny vandals delicious, and their diet keeps the numbers down, helping protect the environment for themselves and many other creatures.

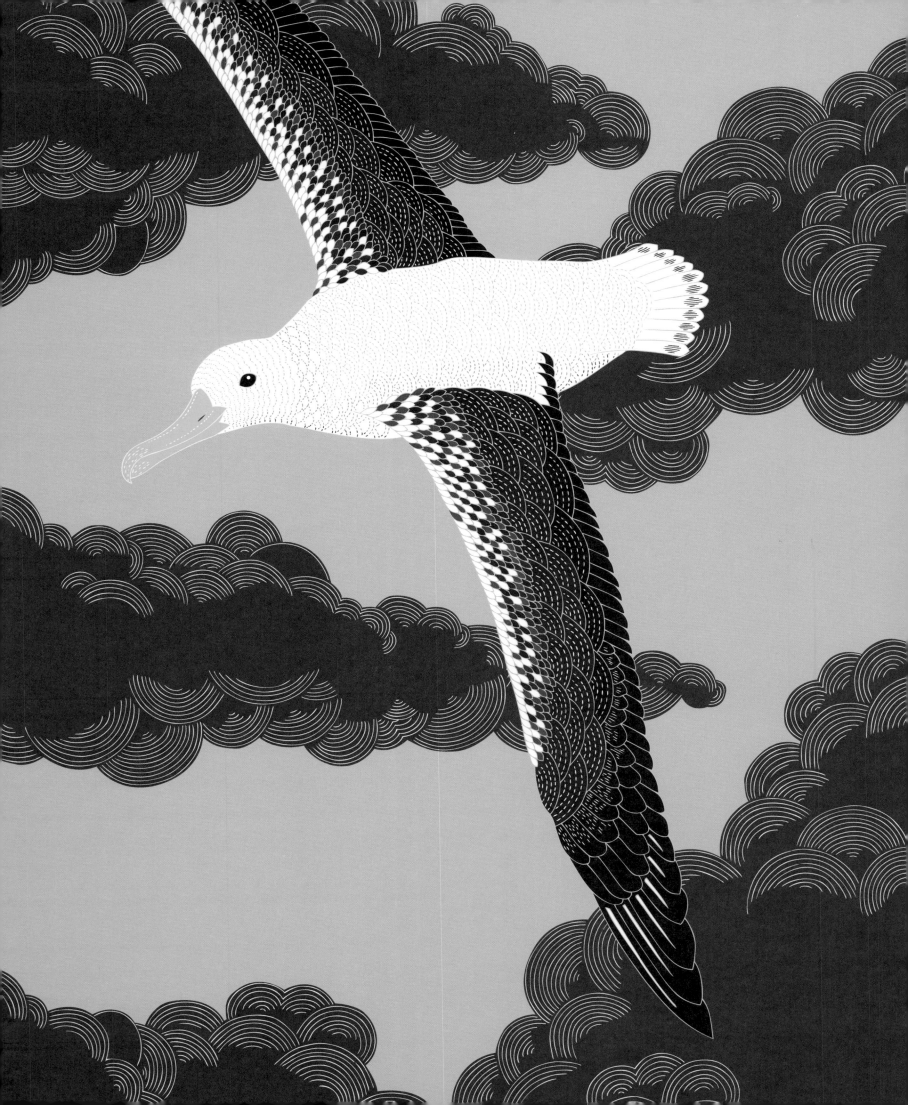

Wandering Albatross

Of the twenty-two species of albatross, the wandering albatross is the long-distance champion—by the age of fifty, a single bird may have flown the equivalent of nearly 149 times around the globe. Using the techniques of dynamic soaring and slope soaring, it can glide hundreds of miles in one day without a single flap of its wings. To gain height, it turns to face the wind, rising on the updraught until it can rise no more, then it tips downward, accelerating quickly, ready for another upward turn. It's a neat trick, as is saving energy with a clever shoulder lock: Its wings stay outstretched without any muscular effort, and the bird flies in its sleep by locking its wings open and shutting down one half of its brain.

The wandering albatross comes ashore only to breed, and it mates only once every two years, having just a single chick. The parents are devoted, traveling thousands of miles to bring back a single meal. Seven to nine months after hatching, the chick is ready to fly the nest; once airborne, it may stay at sea for up to ten years.

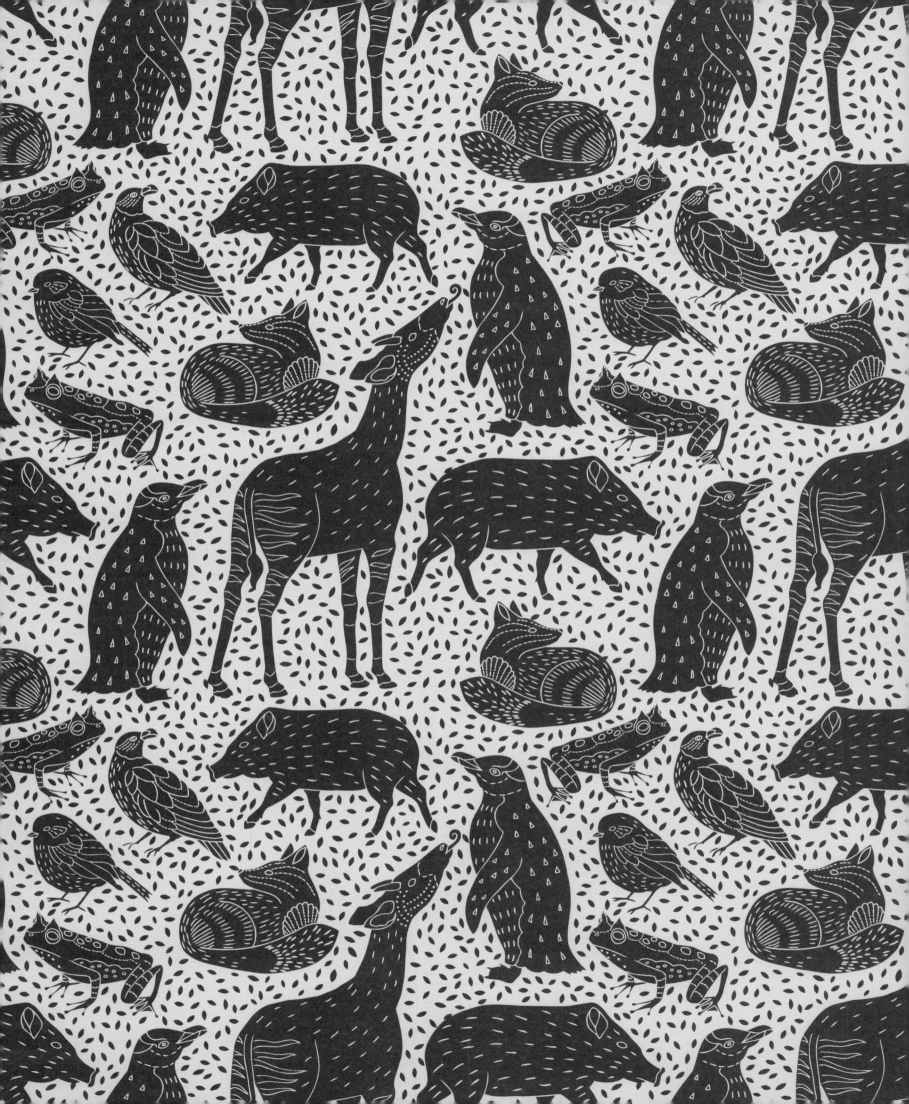

Forests

Forests cover one-third of the Earth's landmass and are found in every continent except Antarctica. In vibrant tropical forests, temperatures stay warm and rain falls abundantly throughout the year; temperate forests enjoy warm summers and cold winters, their deciduous trees shedding autumnal leaves; boreal forests, with pines and firs, thrive with short-lived summers and long, bitter winters. From forest floors, through dense understories, to the tips of the tallest canopies, creatures in their thousands occupy every centimeter.

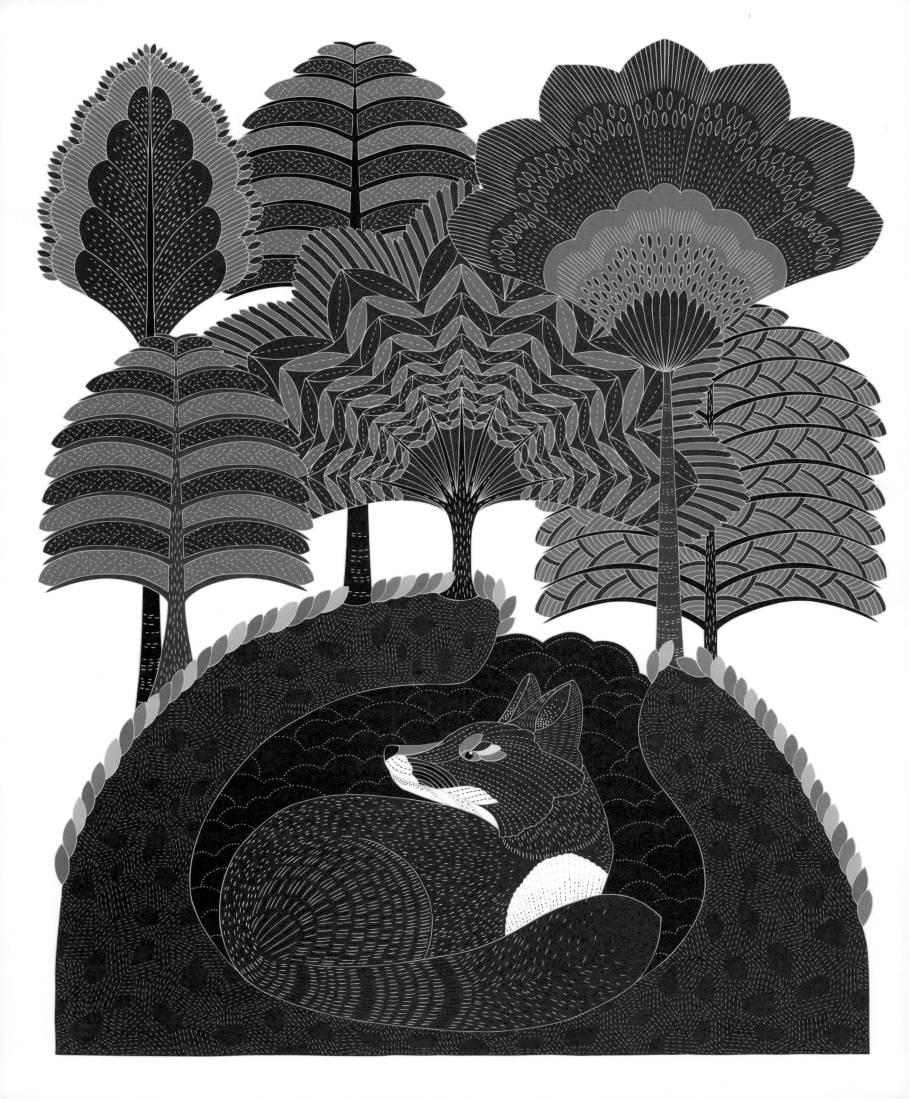

Darwin's Fox

When the HMS *Beagle* landed on Chiloé Island off Chile in 1834, twenty-five-year-old Charles Darwin was keen to see a fox that lived there, different from those on the mainland, with a broader head, shorter legs, and a darker coat. He discovered it sitting on the rocks above the *Beagle*, watching the mariners aboard the ship.

Darwin claimed it to be a new species, and this was confirmed in 1996 when the fox's DNA was studied: The foxes had diverged from a common ancestor some 275,000 years ago and are actually related to wolves and jackals but have evolved to resemble a fox.

We are still trying to learn more about the sweet-natured Darwin's fox, a challenge due to their low numbers. The last estimate was 227 on the mainland and 412 on the island, a minimum total of just 639.

Foxes are extremely resourceful and adaptable, found across the world in almost every habitat, from the freezing Arctic to arid desert plains, but Darwin's foxes can be found in just this one corner of the world. Recently, however, there have been rare sightings further away, an exciting discovery: Perhaps the population is bigger than previously thought?

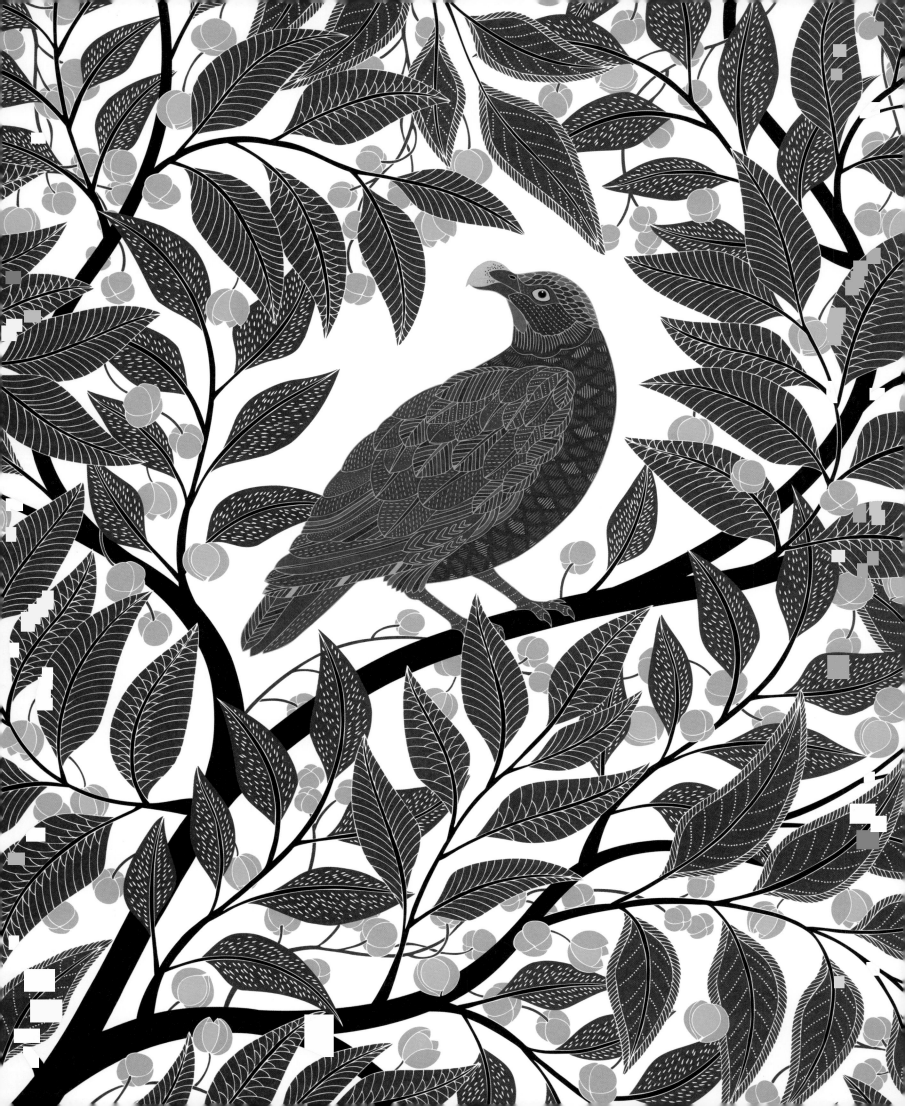

— A true original —

Little Dodo Bird

In 1662, on the island of Mauritius, the very last dodos disappeared as Europeans, and the pigs, cats, and rats that came with them, hunted these curious, flightless birds to extinction. Fast-forward almost two hundred years, and the little dodo bird, one of the dodo's oldest living relatives, was discovered by Western explorers as they stumbled through the thick-forested islands of Samoa.

It's very hard to spot a little dodo bird. They live only on the islands of Samoa, where they are the national symbol and known as the *manumea*, and are extremely secretive. Only a few centimeters bigger than a blackbird and with dark feathers providing excellent camouflage, only one sighting has been recorded since 2013, and none in the decade before that. Masters of hide-and-seek, they fly through the forests surprisingly quickly given their stout shape and short wings, easily giving scientists the slip. Not a single nest has ever been recorded; we don't even know if they nest on the ground or in trees, nor do we know for certain how long they live. But one thing we do know is this unique bird is not closely related to any other living species on Earth. It is a true original.

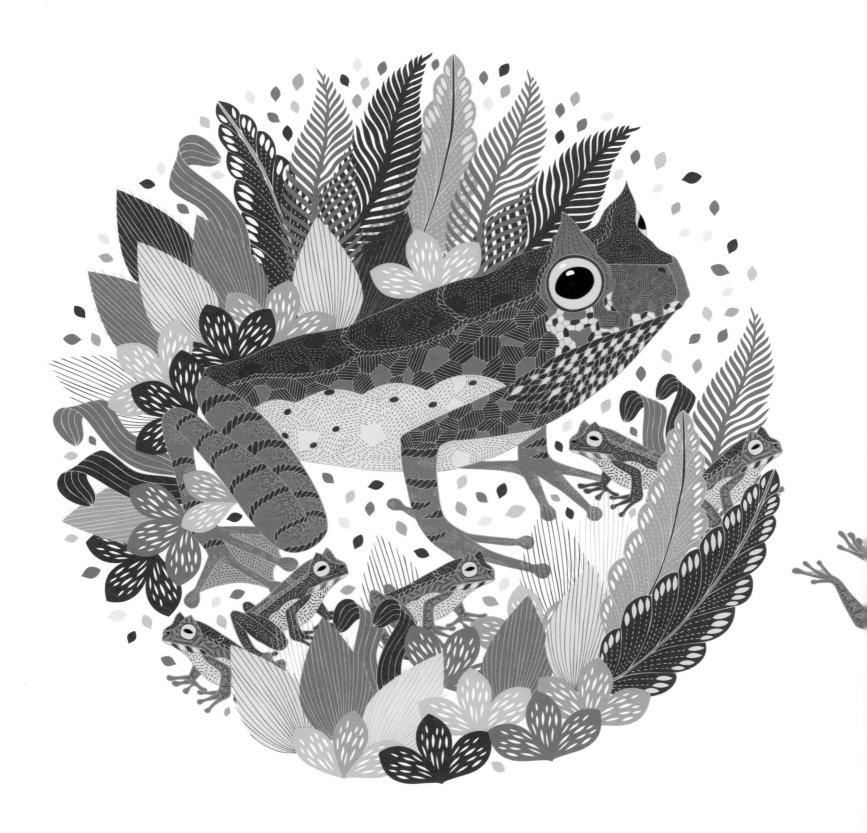

Horned Marsupial Frog

A marsupial is a mammal whose young are born very early in their development, while they are still quite helpless. After birth, they climb up to a pouch on the mother's belly, where they are carried and suckled until fully developed—think of kangaroos and koalas. The horned marsupial tree frog isn't a mammal—like other frogs, it's an amphibian—but it does things a little differently. While most frogs lay their eggs in fresh water, this species keeps its fertilized eggs safe in a pouch on the mother's back. They are pushed into the pouch by the male, where they remain protected from the mouths of hungry predators while they develop into tadpoles, then froglets, emerging fully formed sixty to eighty days later, little horns and all.

But a deadly infectious fungus is wreaking havoc across amphibian populations worldwide, and even the most dedicated frog parents cannot protect against it. Currently, there is no way to control it among frogs in the wild. Thankfully, in Panama there is a breeding program that aims to safeguard a future for these tree-dwelling frogs, who evolved their marsupial-like behavior 40 million to 60 million years ago to become the ultimate bodyguards of their defenseless young.

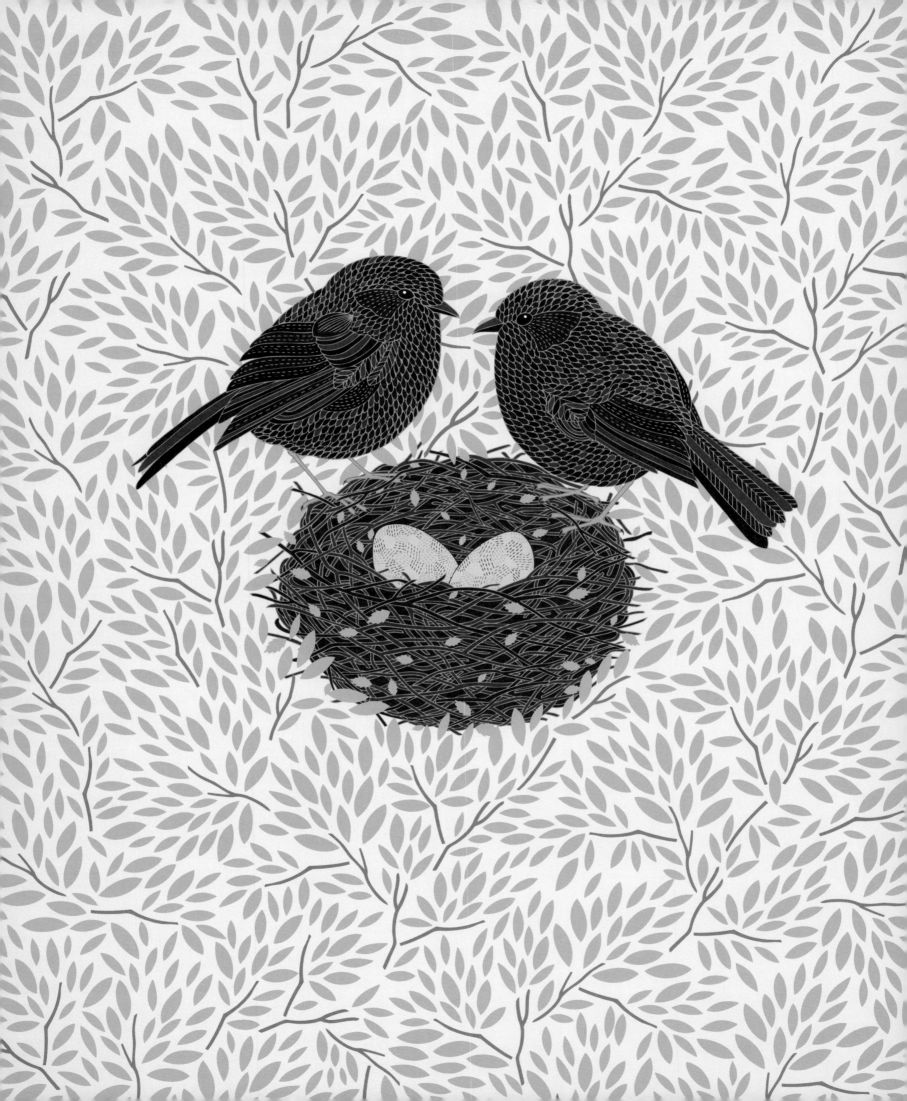

Black Robin

All black robin eggs contain the descendants of a single pair of birds, a female named Old Blue and a male named Old Yellow. When Captain Cook sailed into New Zealand in 1769, the cats and rats aboard went on to decimate the black robin population. By 1976, only seven birds remained, and conservationists moved them to Mangere Island, planting 20,000 trees to provide a habitat. Even so, by 1980, two of the birds had died and none had bred.

Among the remaining five was just one breeding pair, but Old Blue was very old: At eight, she had survived twice as long as the average black robin—and black robins raise only one or two young per year. To increase the population, conservationists removed their eggs to be hatched and raised by foster parents, to encourage Old Blue and Old Yellow to lay more eggs.

Warblers failed as surrogate parents, unable to feed the chicks enough; tomtits succeeded in this, but the chicks grew up thinking they were tomtits and only wanted to mate with tomtits. The solution was to place the fostered chicks back into the care of Old Blue a few days after hatching—success!

Today, there are more than 250 mature black robins living on Mangere and Rangatira islands.

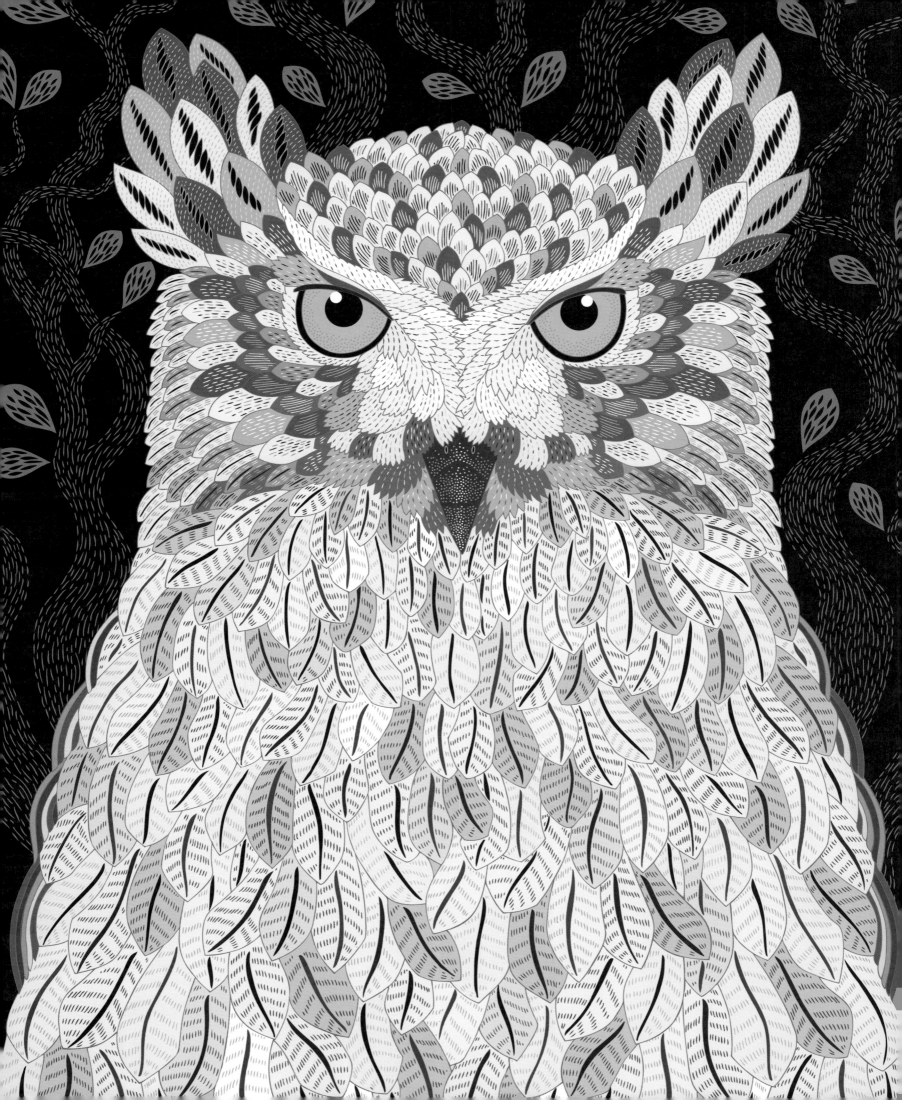

Blakiston's Fish Owl

The world's biggest and most endangered owl lives in the riparian forests—forests near water—of southeastern Russia, northeastern China, and on Hokkaido Island in Japan. Females, who are often 25 percent bigger than males, stand at just over 27 in tall, the size of a three-year-old child, with a wingspan of almost 6 ft. With its size and big ear tufts, in dusky light it can easily be mistaken for a lynx or, sometimes, even a bear.

The Blakiston's fish owl is a creature of the night, descending in darkness to the water's edge to fish. It can pull a salmon two or three times its weight from the river, but salmon are being overfished, and owls can also get caught in the nets laid for them. And there are other threats: deforestation, illegal or unsustainable logging, bush fires, and cars on the roads in the old-growth forests where they nest.

It can be difficult to persuade people to protect an owl they've never heard of. But the owl has found an unlikely ally in the Amur tiger, a "flagship" species for conservation. Efforts to stop further devastation of the tiger's habitat by asking logging companies to close unused roads and limit human access might benefit this anonymous owl too.

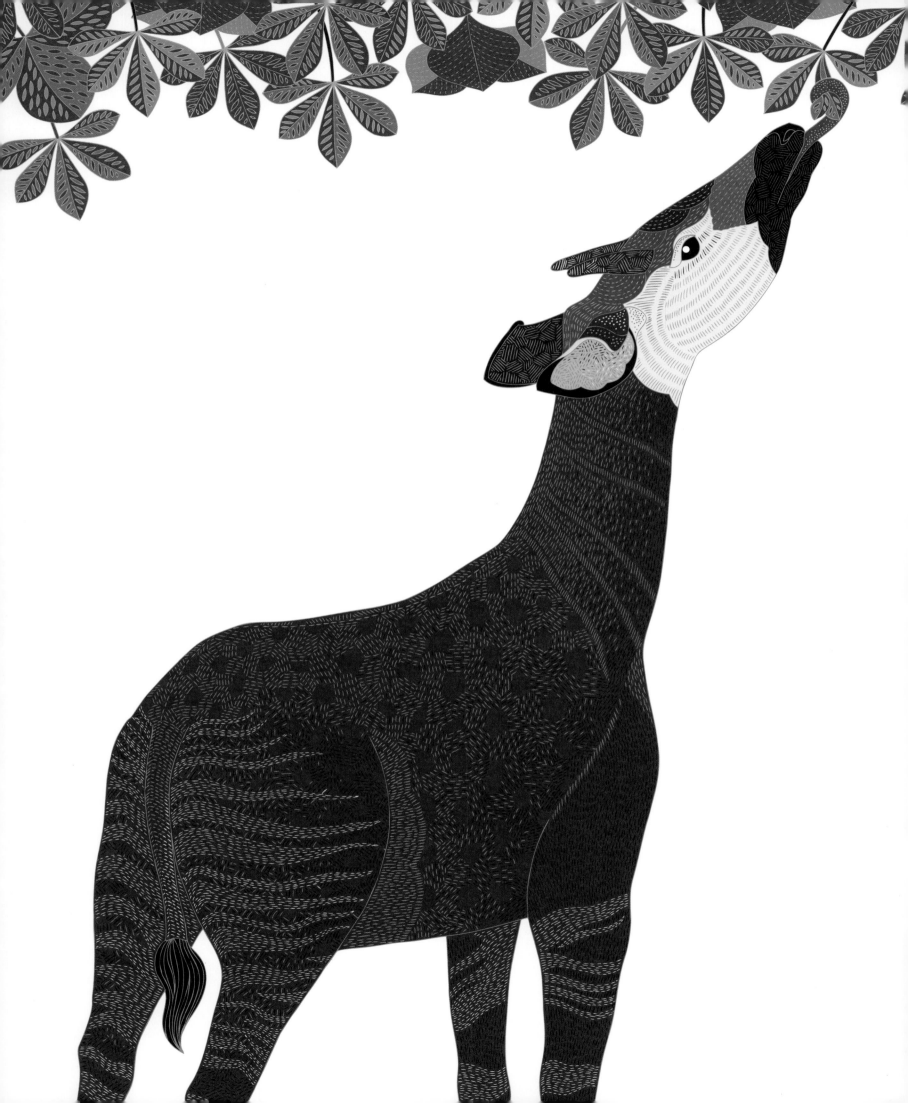

— The forest giraffe —

Okapi

A surreal-looking animal, the okapi appears to be made up of bits: part horse, with the stripes of a zebra on its legs, some deer-like features, and a hint of brown cow. It had people baffled for years and became known as the "African unicorn." Scientists argued that it was either a donkey or a zebra, while jungle tribesmen believed it to be a horse, but in fact the okapi's closest relative is the giraffe: It has the same dark-colored tongue and long neck, and it even walks like a giraffe, with the two legs on one side of its body moving together, whereas other hoofed mammals move alternate legs.

Sometimes called forest giraffes, okapi live in the lush, lowland rainforest of the Democratic Republic of the Congo. A mother, not too far away from her calf, chomps her way through leaves and grasses, even some poisonous fungi. To tolerate them she eats charcoal from lightning-burned trees; the carbon is a superb antidote to the toxins. The mother and her calf communicate in a secret language, unheard by predatory leopards or humans, at very low frequencies, much like the infrasonic sounds used by species such as elephants, whales, and alligators.

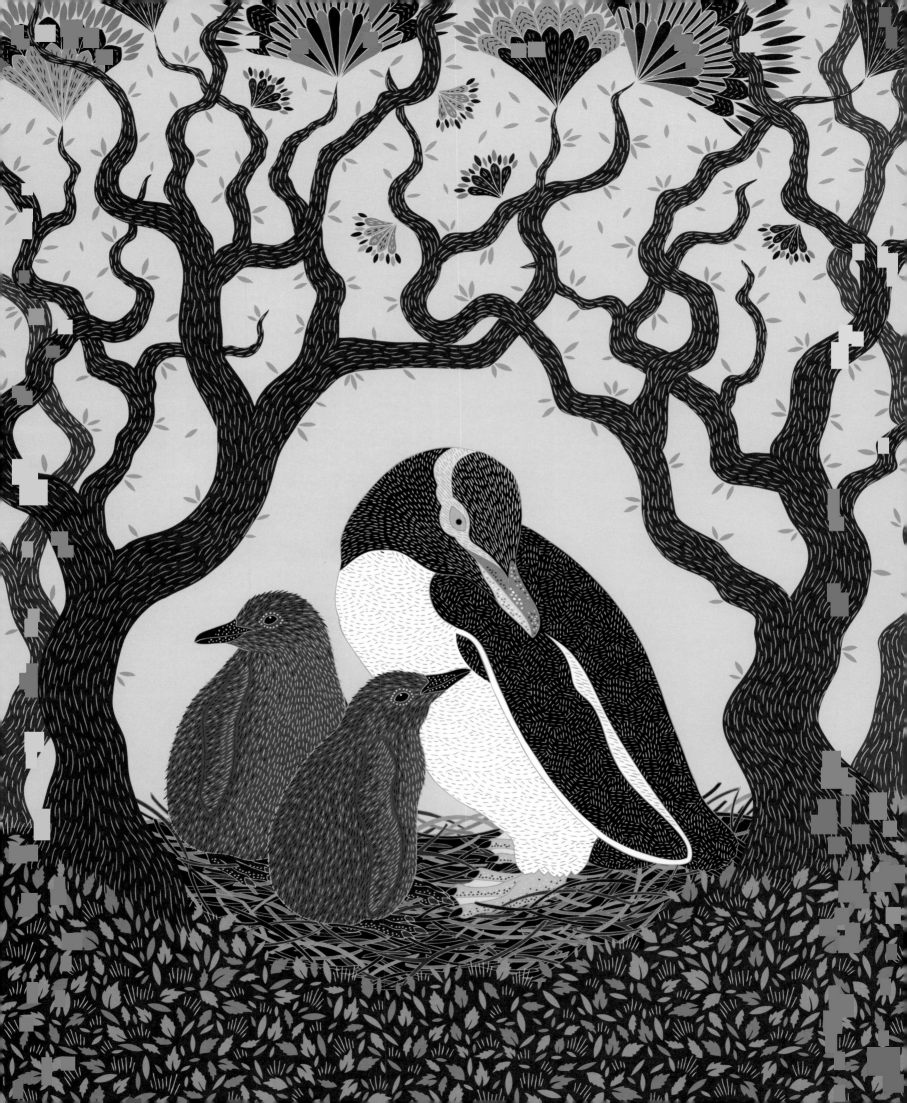

Yellow-Eyed Penguin

The yellow-eyed penguin is a noisy bird with a shrill call. It also goes by the Maori name "Hoiho," meaning "noise shouter." Found only in New Zealand, it appears on the country's five-dollar note. With only 3,400 left in the wild, it is considered the most endangered penguin in the world—threatened by predators on land such as stoats, ferrets, and feral cats, and in water by sharks and sea lions, but the biggest danger is trawler nets.

Like all penguins, they waddle about clumsily on solid ground, but they more than make up for it in the water, zooming around like torpedoes up to 10 miles offshore as they dive deep for fish and squid. Once the fishing expedition is over, belly full, it's time to head back to the nest. As dusk falls, after an exhausting day at sea, penguin parents haul themselves out of the water and begin an arduous trek. Scrambling across rocks and clambering through dense vegetation, often uphill—quite a marathon for stumpy little legs—home to their hungry chicks, who are eagerly awaiting their fish supper. While the chicks are young, the parents take turns making this journey every day, the other staying behind to keep guard.

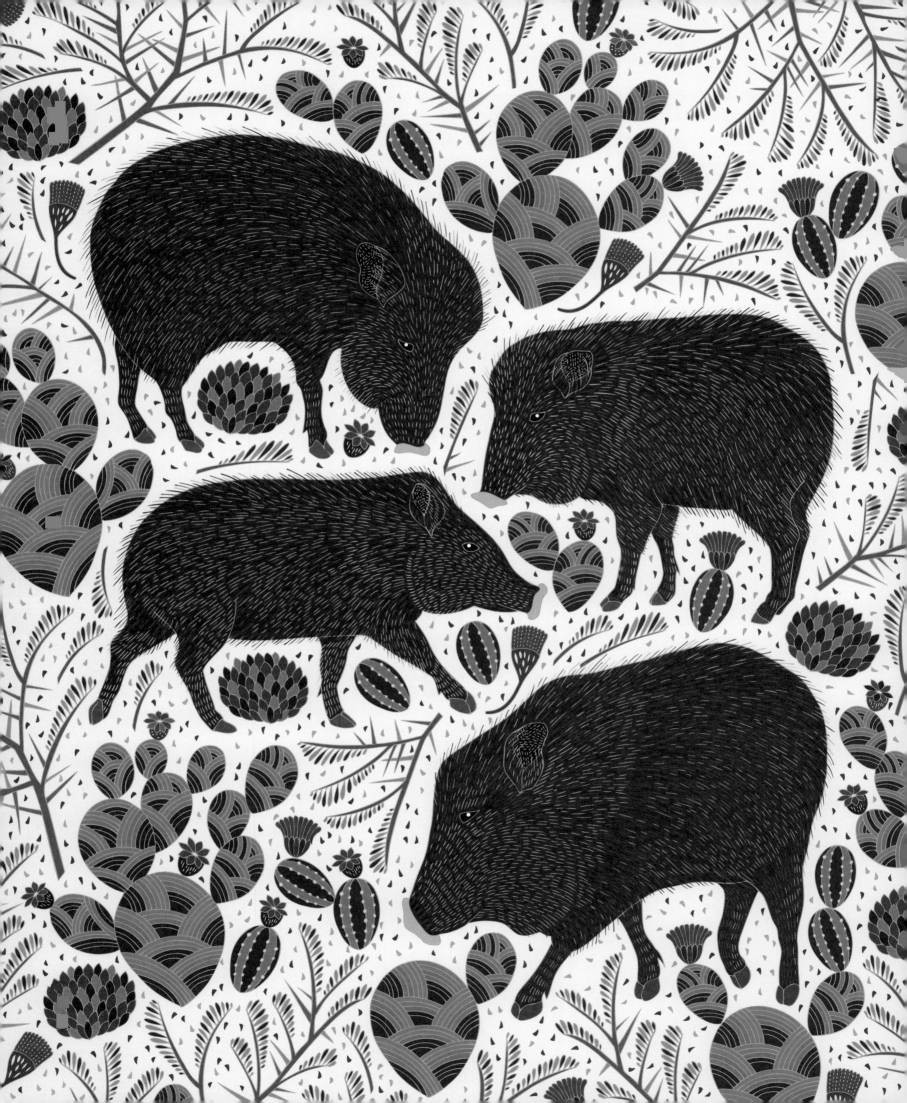

Chacoan Peccary

The Chacoan peccary has been given the bizarre nickname "pig from green hell" because it lives in the driest parts of the Gran Chaco, a lowland plain encompassing parts of Bolivia, Paraguay, and Argentina where thorny scrub and cacti dominate. Only discovered in 1975 (before that it was known only by fossil records), this peccary has an oversized head; big, hairy ears; a bristly coat; skinny little legs with pointy feet; and a piggy snout that it uses to roll the cacti around, knocking off the spikes before eating the flesh. They also eat the roots of bromeliads—plants with stiff, spiny leaves. The peccary's stomach has two chambers, allowing it to digest such tough meals. It even has specialized kidneys to break down acids from the cacti it eats. Ant mounds serve as tasty salt licks, providing essential minerals. Not quite vegetarian, peccaries have also been known to eat small mammals.

Luckily, few predators can survive in this thorny environment; hunters after "bushmeat" have been the main threat. But the peccary's bristly coat provides camouflage and protection from prickly bushes, and their little feet can quickly pick their way across the unforgiving forest floor, helping them escape pursuit.

— Deserts —

From the burnt-orange sand dunes of the Sahara to the windswept mountains of the Gobi, from the icy expanse of the bitter polar regions to the rugged terrain of the Mojave, deserts have one thing in common: Rainfall is rare or non-existent. Deserts cover about one-fifth of the Earth's surface and are among the most inhospitable habitats on the planet. It's hard to imagine anything surviving, let alone thriving, in them, but they brim with life.

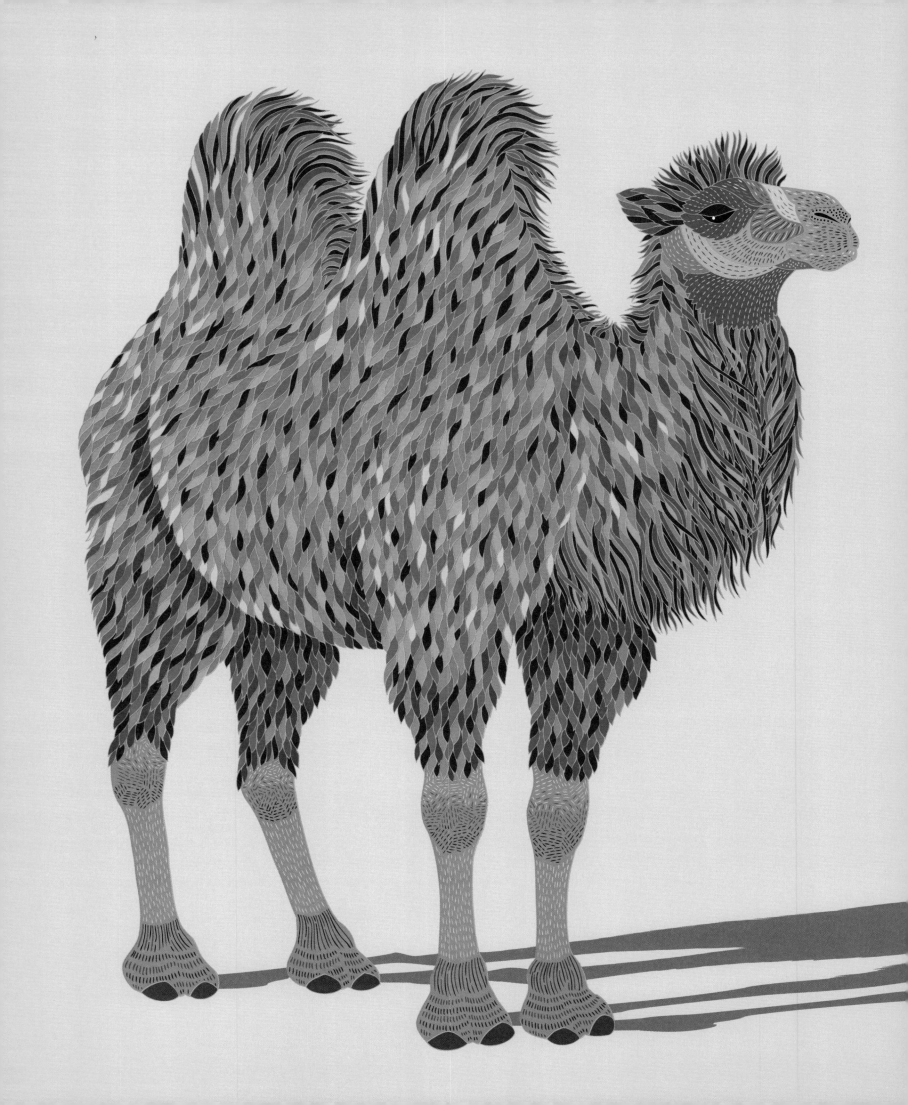

Wild Bactrian Camel

The wild Bactrian camel is the only wild camel still to exist. This hard-core survivalist is equipped to live in one of the most inhospitable places on the planet: the Gobi Desert, the largest desert region in Asia, covering 500,000 square miles and spanning the border of northern China and southern Mongolia.

Water and food are scarce, so stocking up when possible and storing calories in a couple of backpacks as fat to convert into energy later is a good idea. Saltwater springs may be the only drink available, so a tolerance to saltwater is a must. Summer temperatures reach 122°F, while winters plummet to -40°F, so you need a coat that is thick and shaggy in the winter but molts in the summer. Navigating rocky terrain and shifting sands requires big padded feet like snowshoes, and protective eyewear is necessary to guard against the sand-blasting desert winds: two eyelids with extra-long eyelashes, with a third underneath to wipe the eyeball free of dust. Sealable nostrils also come in handy.

And last but not least, have some form of radiation-proof protective gear, in case you arrive at the part of the desert that China used as a nuclear weapons testing site for forty-five years. The wild Bactrian camel survived that too.

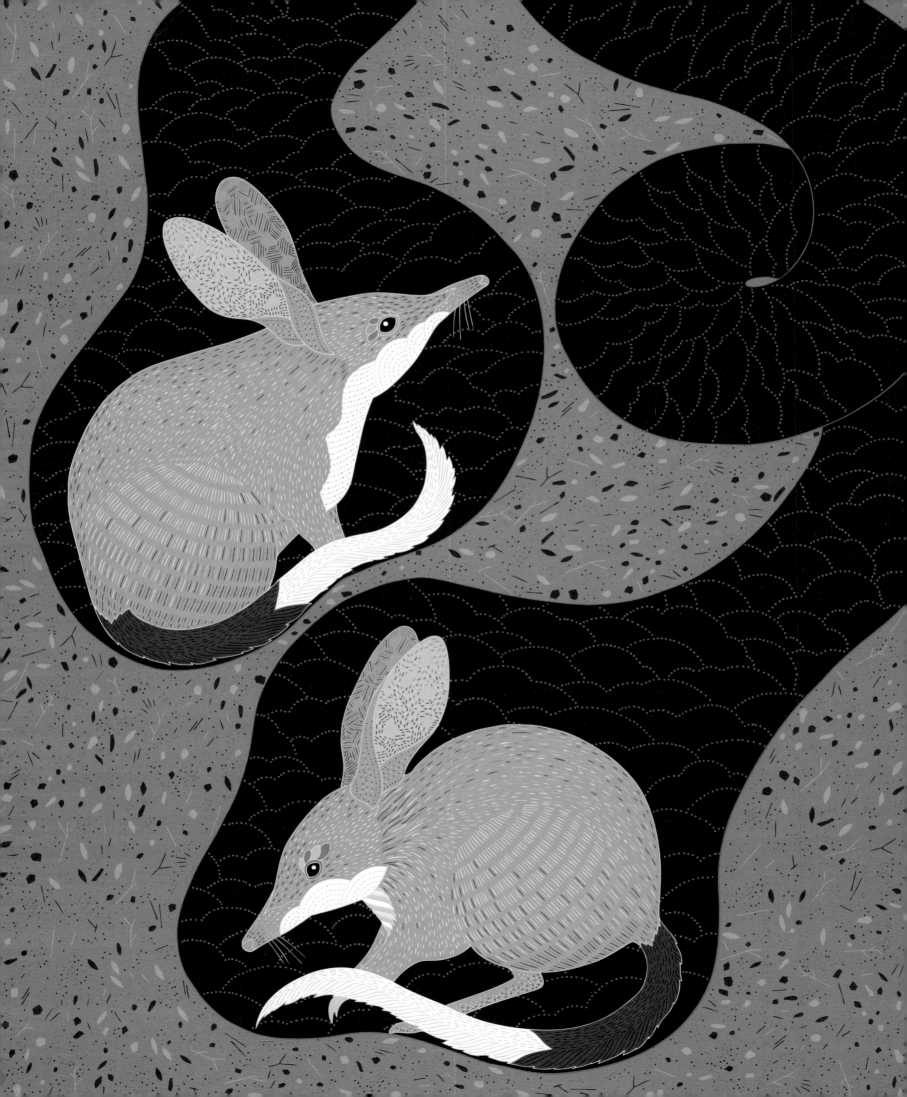

Greater Bilby

Bush fires in the dry, searing heat of the Australian desert can be devastating for wildlife. But fire can also bring life, freshening stale vegetation and encouraging new growth. In the days after a fire, soft, green shoots emerge from the ground, and the greater bilby is rather partial to them. Having waited out the flames deep underground in its nine-foot-long spiral-shaped burrow, it emerges at night to sniff out the cool, charred earth above and it snuffles around for tasty grubs with its highly sensitive long nose, its huge, bunny-like ears listening for danger.

The word "bilby" is an Aboriginal one meaning "long-nosed rat." Having frolicked around Australia for 15 million years, they now survive only in small patches, and even smaller numbers, across the desert areas of Western Australia and the Northern Territory, with one lonely, isolated group clinging on in Queensland. The bilby is under attack from non-native predators—feral cats and foxes—and rabbits, another imported species, create enormous competition for food.

The greater bilby is the world's only surviving species of bilby, but its rarity—and its cuteness—has sparked an unusual campaign. Easter chocolate bilbies are taking the place of chocolate bunnies in Australia, a tasty way to raise awareness and funds!

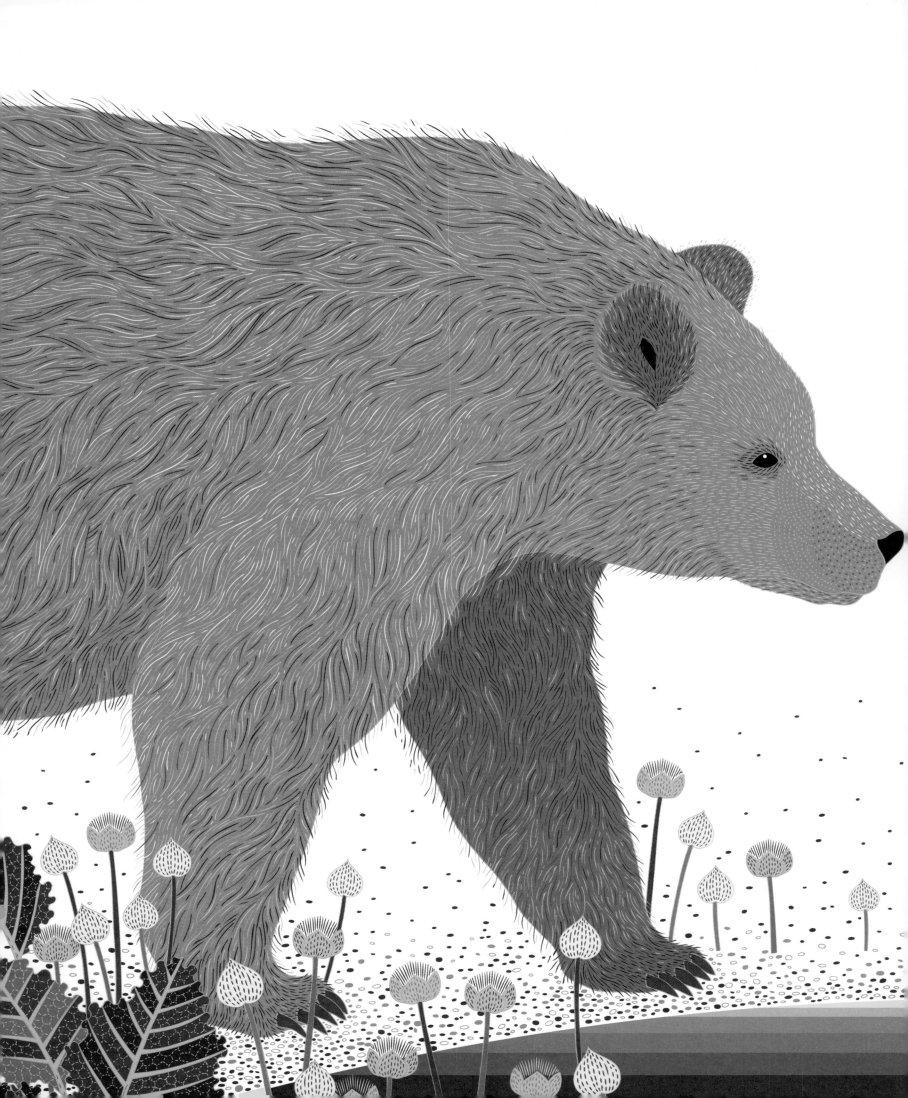

Gobi Bear

With the rising sun, the Gobi Desert comes alive with all manner of creatures: lizards, falcons, gerbils, polecats, camels, ibex, and many more. In the craggy terrain, a smallish bear with a shaggy golden-brown coat emerges from hibernation with the arrival of spring and starts foraging for wild rhubarb roots, berries, grass shoots, wild onion, and perhaps the occasional rodent. The bear drinks its fill of fossil water—rainfall from centuries gone by, found in sparse oases, which are areas in the desert where water comes up from deep underground. These oases are vital, as some parts of the Gobi Desert get no rainfall at all.

The *mazaalai*, as the Gobi bear is known to the people of Mongolia, is the only bear in the world that lives entirely in the desert, and it is possibly closer than any other bear to the original ancestral Asian brown bear. It lives alone except when breeding or while a mother raises her cub, and it is thought that there are fewer than forty left, and none are in captivity. These few bears are the very last of their kind, under threat from mining for gold, copper, and coal, as well as poaching. They are clinging to survival in the far reaches of the wilderness.

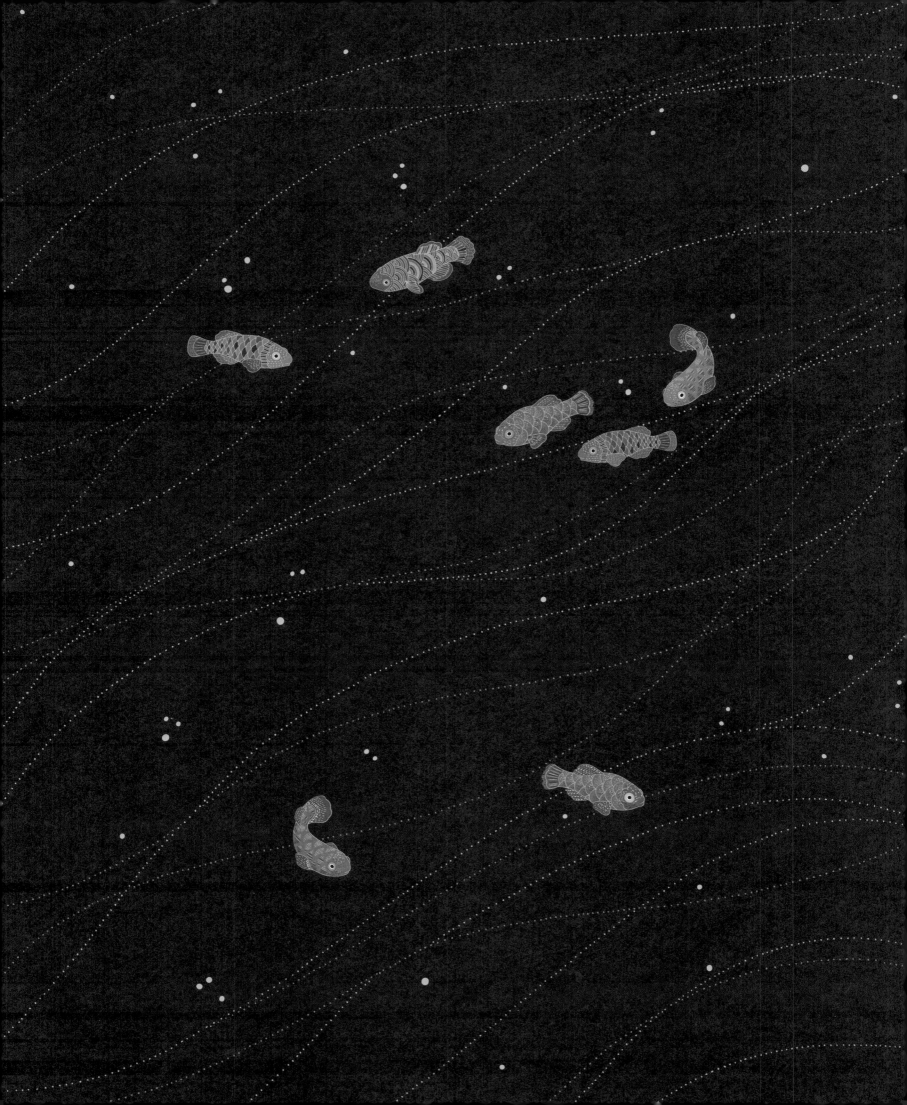

Devils Hole Pupfish

Deep in the salt-encrusted earth of Death Valley in the Mojave Desert lies Devils Hole, a long, narrow opening in the rock leading to a small, flooded limestone cavern more than 500 ft deep. Living there is an extraordinarily tough little fish, each one less than an inch long: the Devils Hole pupfish. One of the rarest of all fish, and the most isolated animal species on Earth, this is their only home in the world. Talk about a fish out of water: How about a fish in the middle of the desert?

Life here is a feat of endurance: The pupfish survive by feeding on algae and the water is the temperature of a bath, lethal to most other fish, very salty, and low in oxygen, so at least predators are not a worry. Or so we thought, until scientists recently discovered in their tank of captive-bred pupfish that tiny beetles, which also live in Devils Hole, prey on the eggs and larvae. But we don't yet know if the beetles are also a threat to the wild population.

So how did the pupfish end up here? Scientists are still puzzled. Were they stranded tens of thousands of years ago when the rivers and lakes dried up? Or were early relatives carried there by birds, evolving to become the pupfish in the last thousand years? The scientific quest continues.

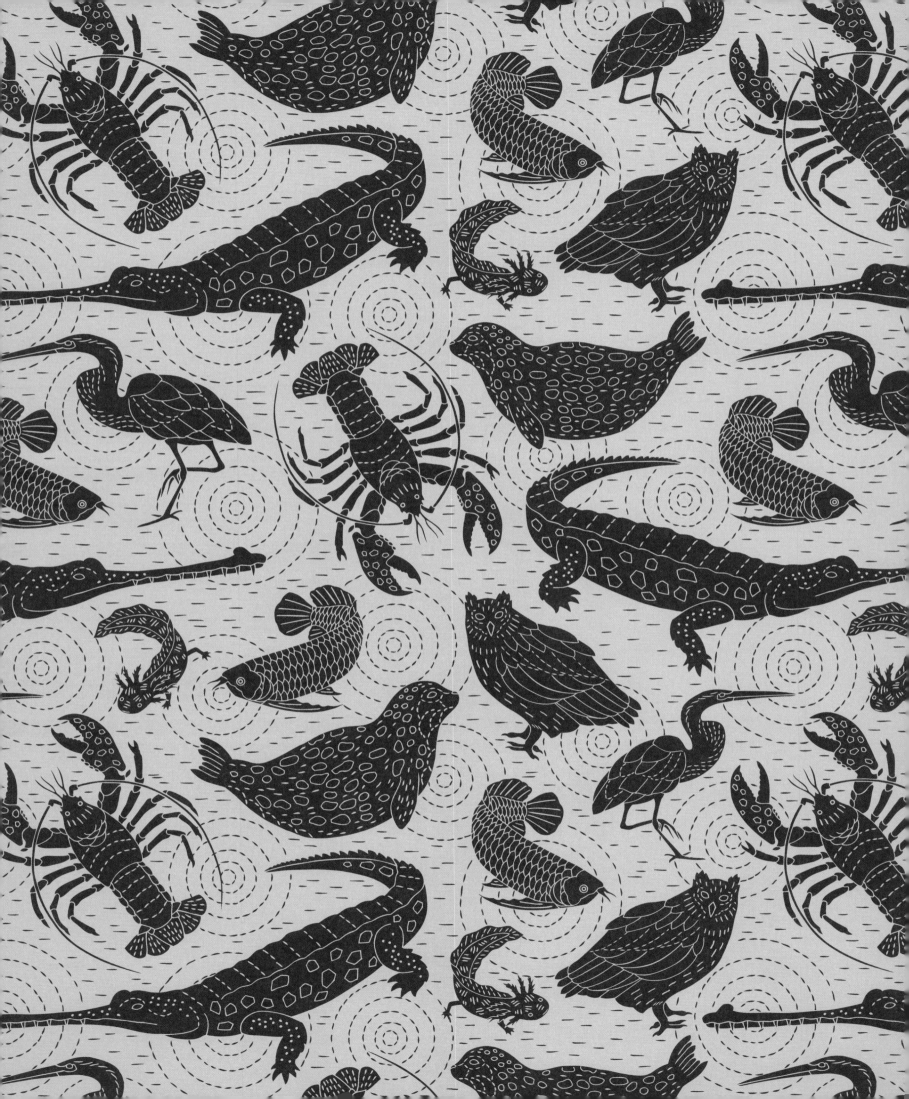

— Fresh Water —

From the murky waters of the Amazon River to the chilly depths of Loch Ness, freshwater habitats are scattered across the globe, but take up a mere 0.01 percent of the planet's surface. But whether it's frigid lakes on mountaintops, idle rivers meandering along valley floors, babbling brooks picking their way through forests, or our very own backyard ponds, fresh water provides a home to 100,000 species, and food, water, and refuge for countless others.

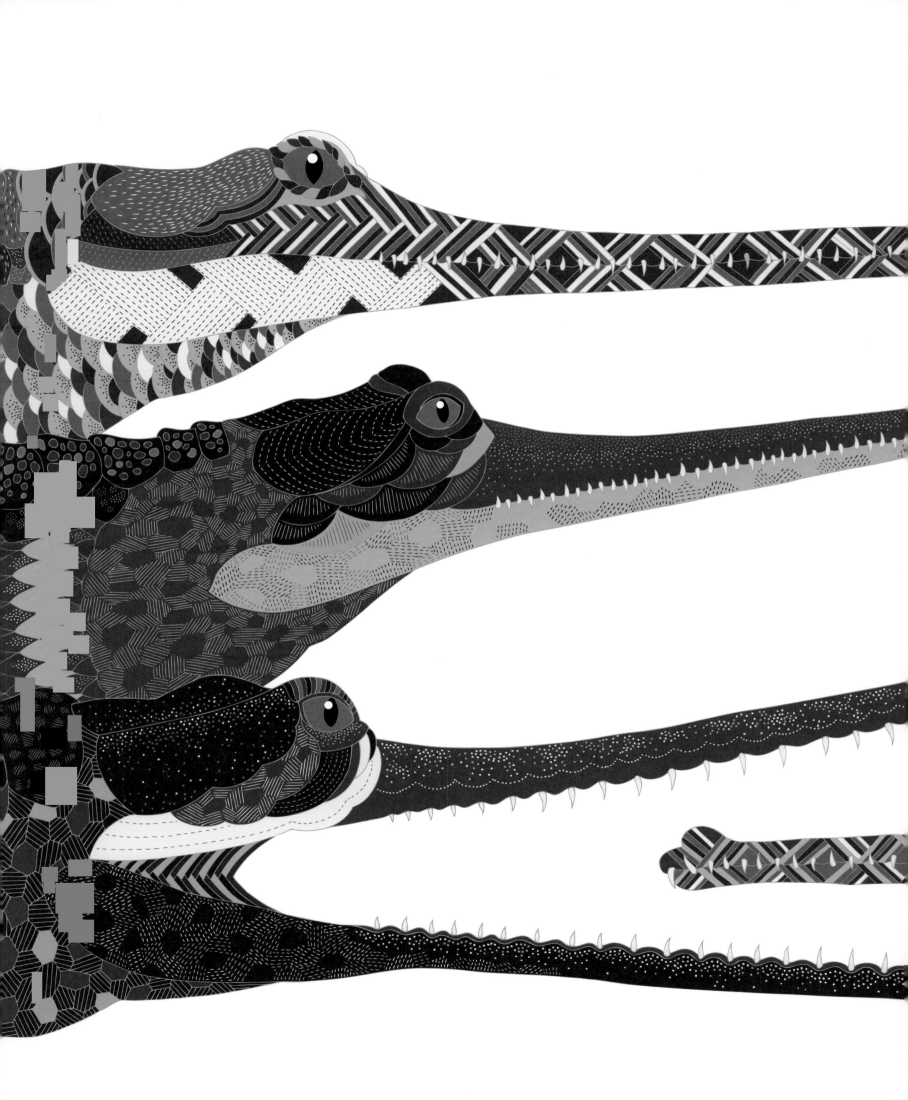

Gharial

Sixty-five million years ago or so, when dinosaurs roamed the planet, a huge asteroid over 5.5 miles wide hurtled into Earth, wiping out three-quarters of the world's plants and animals. But the crocodilian ancestors of saltwater crocodiles, freshwater crocodiles, caiman, and the gharial survived.

The gharial is one of the largest of all crocodilians, the males a monstrous 16 to 20 ft from head to toe, about the same as the biggest great white sharks. Its long, narrow snout, which gets longer and narrower with age, is lined with 110 interlocking razor-sharp teeth, perfectly adapted for snatching up fish under water, and the strange bulbous growth at the end, the ghara, creates a buzzing sound that helps females spot a mature male and may be used as a bubble-blowing device to charm the ladies during courtship.

This is especially important these days as there are only three breeding groups left in the whole of India and Nepal, though in days gone by gharials could be found basking in the sun on riverbanks in Pakistan, Bangladesh, Bhutan, and Myanmar.

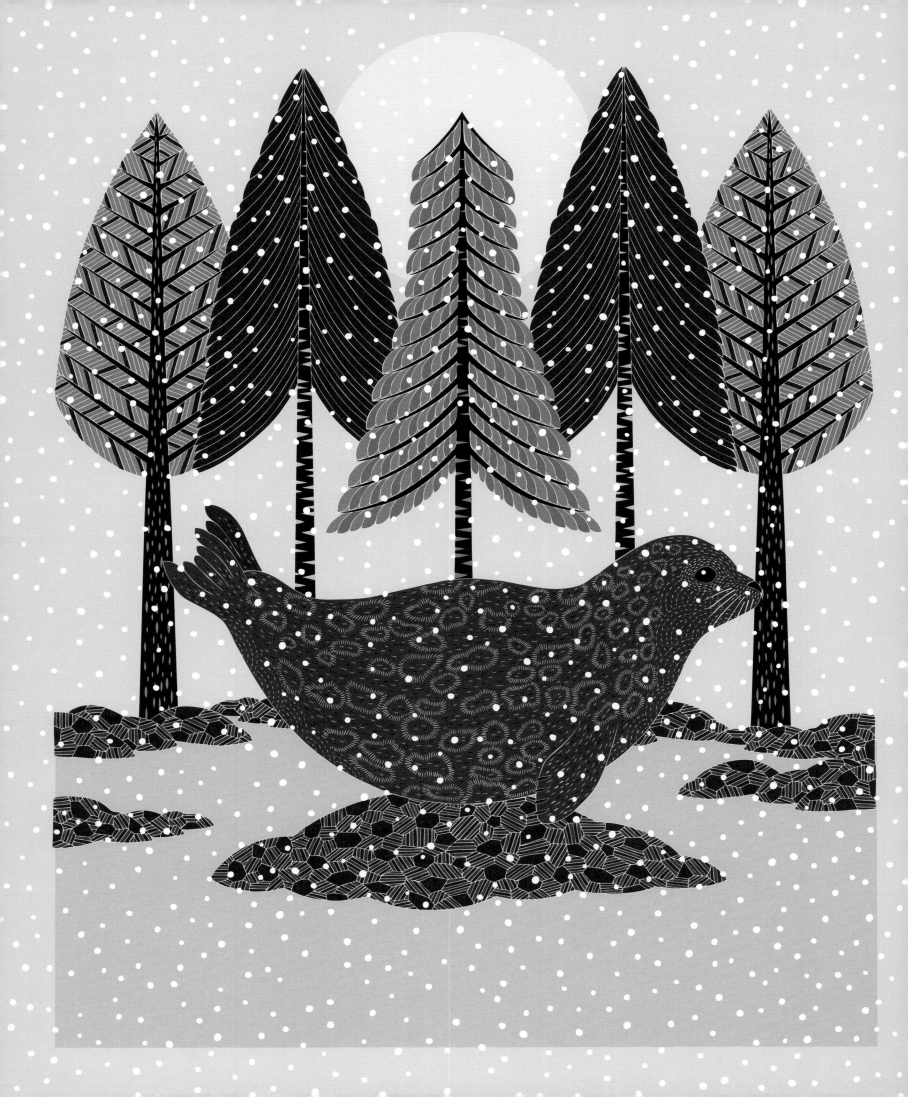

Saimaa Ringed Seal

The Saimaa ringed seal, one of few freshwater seals in the world, has evolved to survive without salt since the end of the Ice Age, when Lake Saimaa in Finland was cut off from the ocean. Each seal's fur has a unique pattern, as individual as our fingerprints are to us.

Graceless on land, layers of blubber moving with every thrust, the roly-poly seal is transformed in the water, agile and perfectly streamlined despite its bulk. So it is not surprising that the seals choose to spend almost all their time in or on the lake. They even sleep in it, floating upright, bobbing about like corks. When it freezes over, they build their dens and give birth on the ice, digging caves out of snowdrifts—their claws are perfect for gripping and carving ice holes—and fashioning a secret entrance in the ice beneath which pups stay dry, warm, and safe from predators.

But rising temperatures have impacted snowfall and, without enough snowdrifts along the icy shores, pregnant seals cannot build their shelters. Thankfully, eager conservationists and volunteers set to work as human snowplows, scooping and shoveling what snow there is to create manmade snowdrifts, perfect for a female looking to build a den.

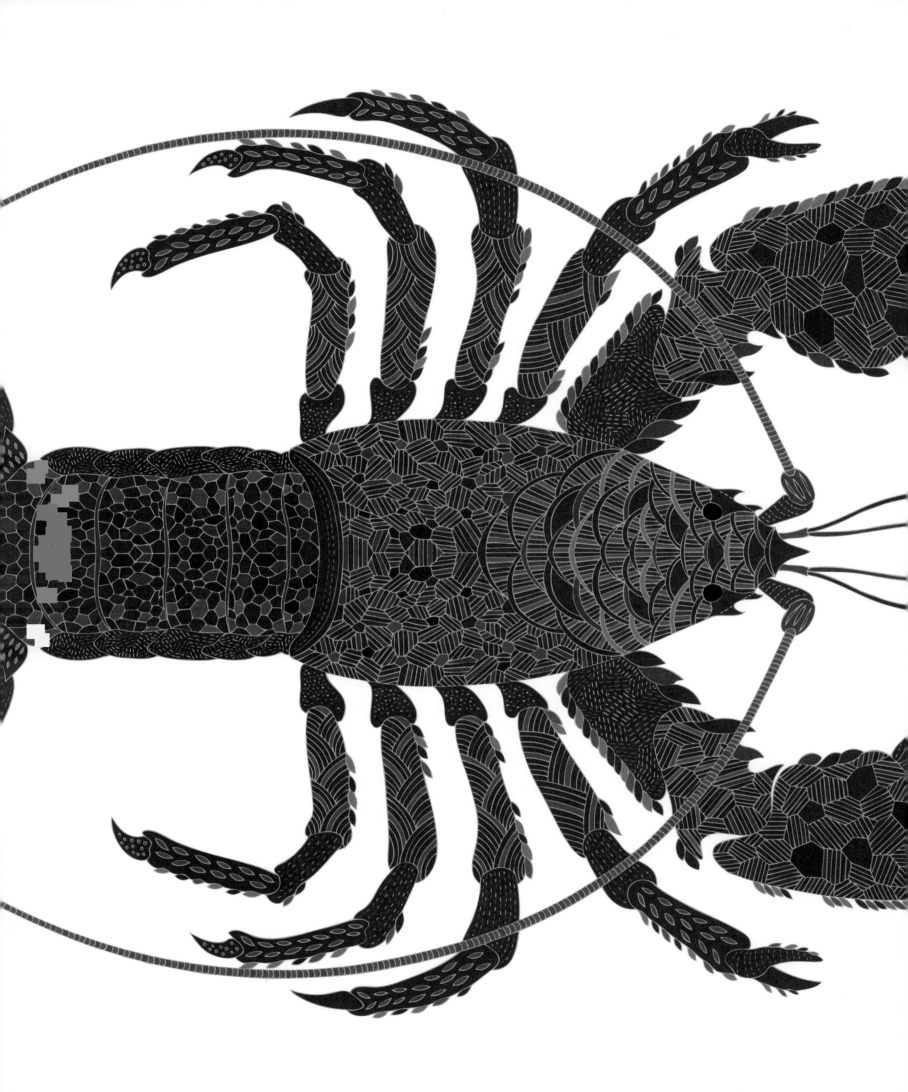

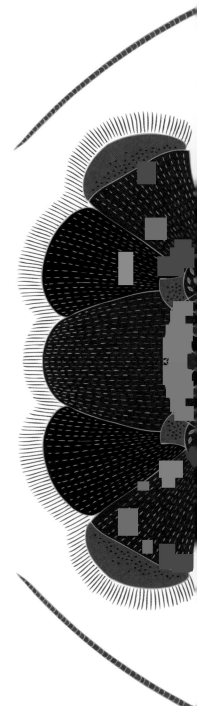

Tasmanian Giant Freshwater Lobster

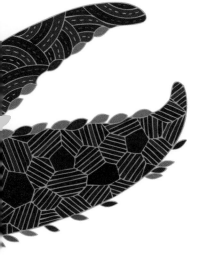

Deep in the rainforest in a remote part of northwestern Tasmania lives the world's largest freshwater invertebrate. The Tasmanian giant freshwater lobster feasts on all manner of delightful stuff—rotting wood, leaves, insects, and the flesh of dead animals that fall into the water and wash downstream—growing from a 6 mm hatchling to a hard-shelled behemoth the size of a Jack Russell terrier with pincers big enough to wrap around your arm and powerful enough to break bones.

The Tasmanian giant freshwater lobster has survived for millions of years, hardly changing in all that time. If left alone in the wild, it can live to the ripe old age of sixty, but it is a slow-breeding species. Females are not sexually mature until fourteen years of age. And they spend the first seven years of their lives hiding among the cobbles and small rocks of the slow-moving rivers until they are large enough to fend for themselves in the open water and escape hungry predators: Birds, fish, and humans alike find them a tasty treat. Today, logging has upped the threat level, with sludge washed into the water from land cleared upstream clogging up the young lobsters' hide-outs and leaving them no place to take cover.

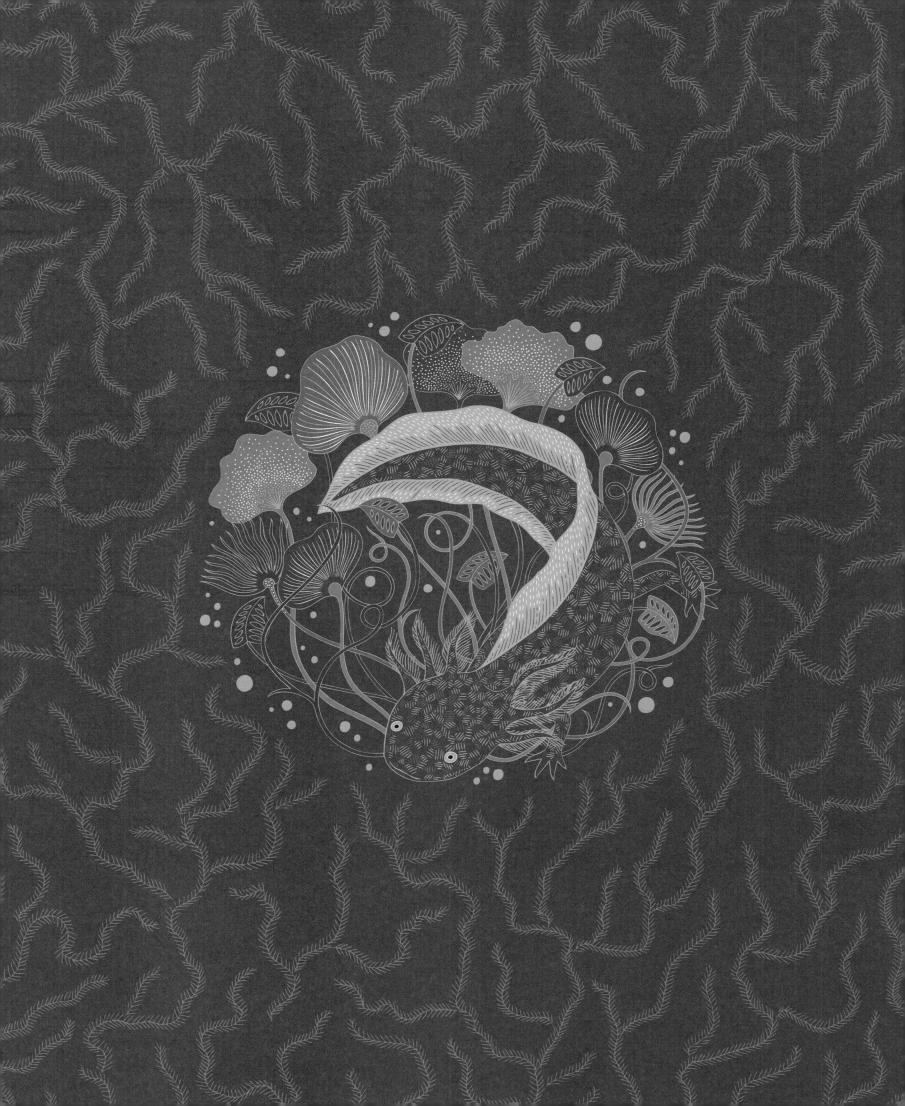

— The amphibian that never grew up —

Axolotl

In the murky waterways of Lake Xochimilco on the southern edge of Mexico City lives the axolotl. Its name means "water dog" in ancient Aztec and legend has it that this "water monster" was an Aztec god who disguised himself as a salamander to escape being sacrificed.

Other species of salamander go by similarly endearing names such as "mud puppy" and "snot otter," but unlike most salamanders, the axolotl never grows up entirely and so lives permanently under water. It resembles an overgrown tadpole, up to 30 cm long with a fin running from its head to the tip of its tail, frilly gills, and dainty little legs.

And there is something else remarkable about the axolotl: Much like its cousin the newt, it can regrow entire limbs again and again, and parts of its internal organs, including the brain. This, along with its ability to stay safely under water as an adult, is an excellent survival strategy, but sadly, polluted waters, invasive species, and overhunting (roasted axolotl is a delicacy in Mexico) are counteracting these strengths. Twenty years ago, there were 6,000 axolotls per square mile; now, there are perhaps thirty-five.

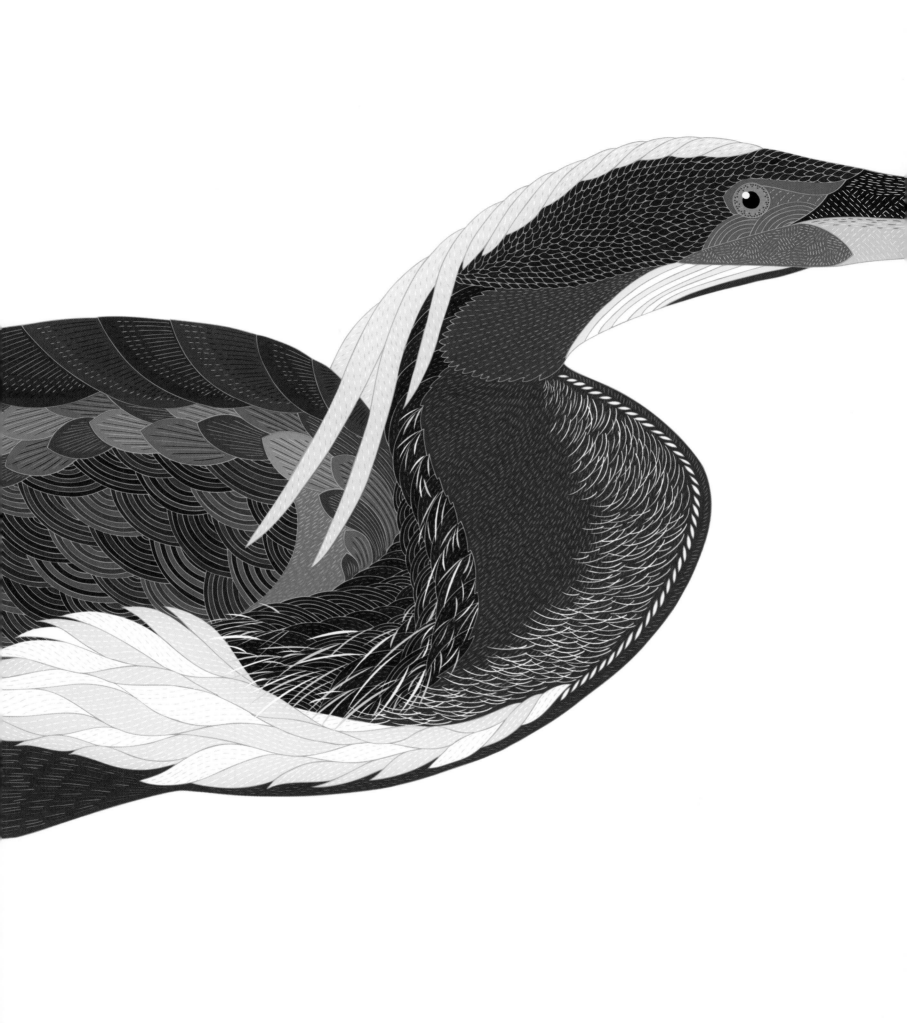

Agami Heron

The Agami heron is considered by some to be the most beautiful bird in the world. With its spear-like beak, elegant neck, fancy headdress, and dazzling plumage, it seems it could exist only in fiction. You'd think it had every reason to show off, but it hides, alone, among the shadows, skulking beneath overhanging branches at the edges of swampy streams, small rivers, and lakes in the tropical forests of Central and South America, places that are often impossible to reach.

It is only in breeding season that this elusive creature emerges from its hiding places and flaunts its feathers, which range from rich chestnut and smoky gray to hot scarlet and myrtle green. Unlike most birds, both males and females boast this glamorous plumage, and it is the female who must win the heart of the male. He lures her to a nesting site he has chosen specially, but then it is up to her to impress him: swaying, snapping her bill, flicking her tail feathers, bowing toward him, her face turning a vivid crimson. He might respond aggressively by snapping his razor-sharp bill and jutting it toward her, but the female persists and eventually gets her man.

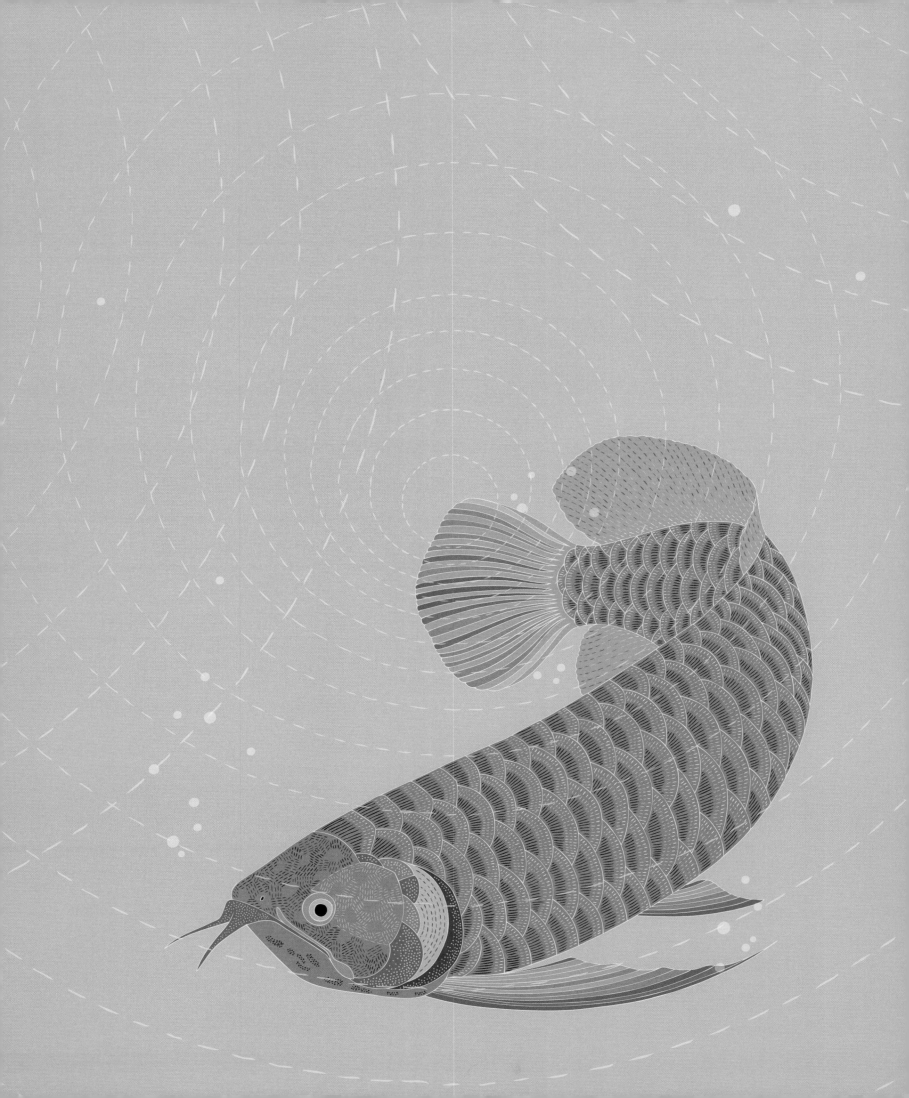

Asian Arowana

A tropical freshwater fish, the Asian arowana lives in swamps, lakes, flooded forests, and deep, slow-moving rivers in Cambodia, Malaysia, Myanmar, Thailand, Indonesia, and Vietnam, its shiny scales glinting like colorful glass as its body glides gracefully beneath the surface. These "dragonfish" resemble the highly decorated Chinese New Year paper dragons and so are thought to bring good fortune.

The Asian arowana is bred in captivity in the hundreds of thousands, but in the wild, extinction threatens. The dragonfish was once just another fish to eat, but because it is slow to reproduce and sits at the top of the food chain, it found itself on the protected-species list. Arowana are mouth-brooding fish—the male keeps his young safe inside his mouth until they are big enough to swim freely—so with every male that is caught illegally, so are its young, and the population takes a big hit. International trade of the wild fish was banned, but the ban created the illusion that the arowana is a rare species and suddenly its popularity, and price, sky-rocketed, with aquarium owners paying thousands of dollars for a single wild specimen.

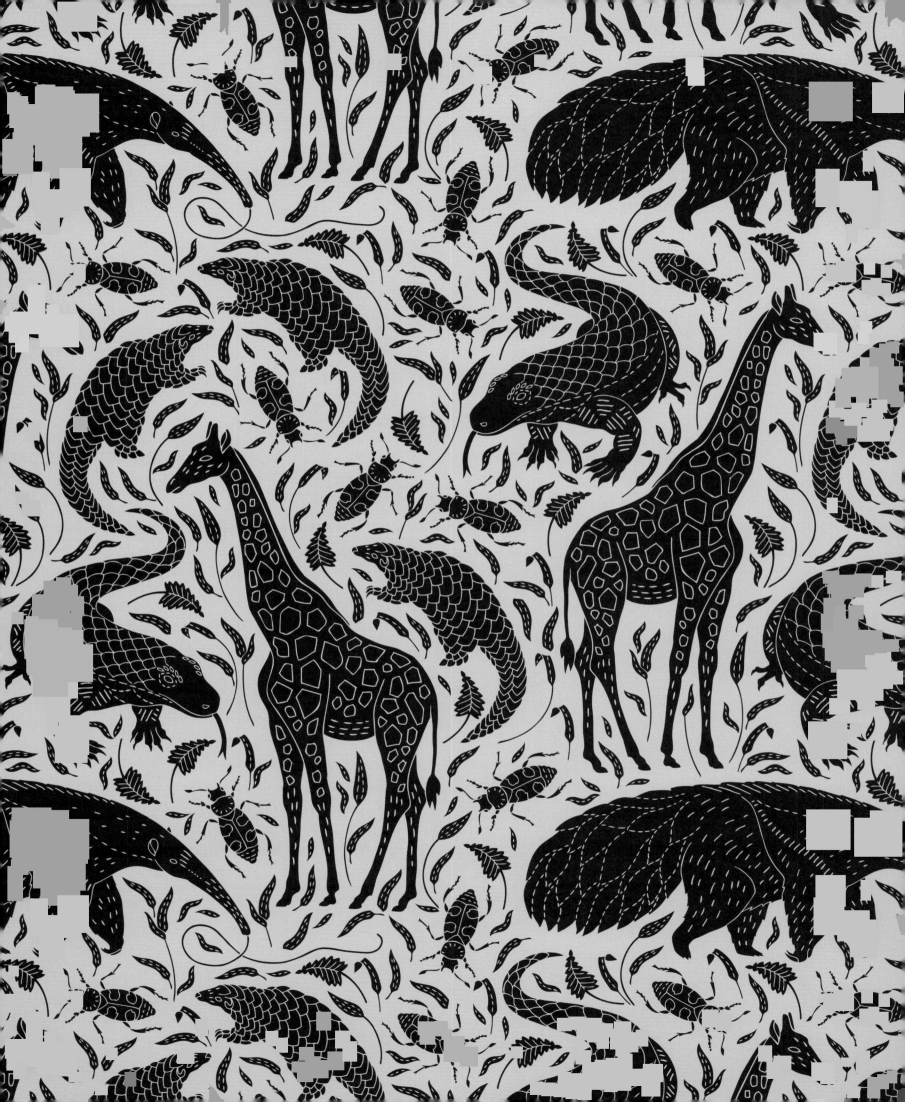

— Grasslands —

Prairie, steppe, savannah, range-
lands, cerrados, pampas . . . Earth's
grasslands are found on all conti-
nents except Antarctica. In these
open, flat landscapes, rain is scarce
enough that trees don't grow in
large numbers, so grasses dominate,
seas of billowing stalks rippling in
the wind. Tropical grasslands stay
warm throughout the year; tem-
perate ones vary in temperature.
Grasses grow back quickly, so there
is always a plentiful supply of food
for the hungry grazing hordes.
Some of the world's largest animals
live here, and some of the smallest.

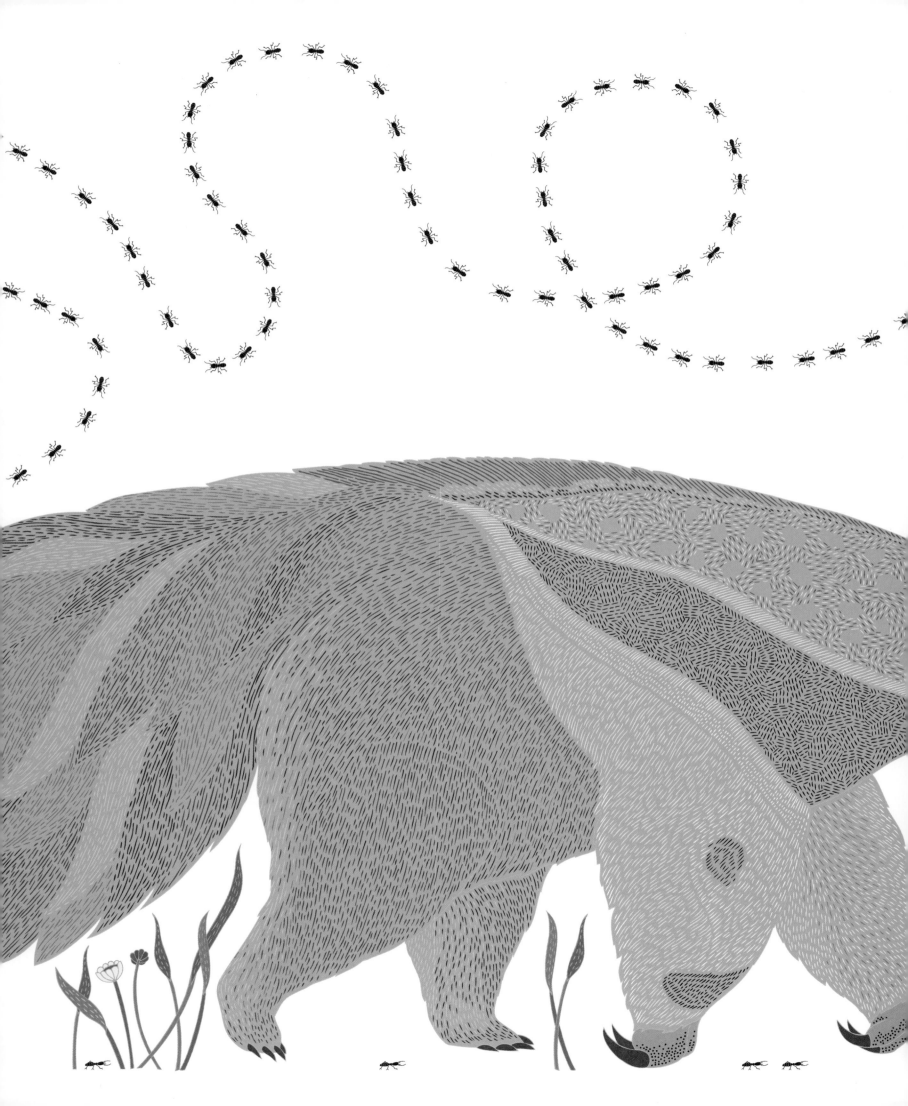

Giant Anteater

The giant anteater may look bizarre, but it is perfectly equipped to forage in the grasslands of Central and South America. Here, there are millions of earthy termite mounds, some 16 ft high, their inhabitants oblivious to the dangers outside. A rustling from the tall grasses, and a long, slender nose pokes out, sniffing the air. It has poor eyesight but a strong sense of smell, forty times more sensitive than our own.

Inside, the termites, protected by the hard exterior walls, are safe from most predators, but not from the giant anteater. With strong front legs and claws measuring 10 cm, breaking in is a piece of cake. The anteater tears a hole in the side and begins slurping up the insects.

It flicks out its saliva-covered tongue, 2 ft long and covered in thousands of tiny hooks, 150 times a minute and scoops up the tasty morsels. The anteater has no need for teeth. Measuring over 6 ft from nose to tail, the giant anteater hoovers up 30,000 insects daily, but its low-calorie diet means it moves around very slowly to save energy and sleeps as much as sixteen hours a day, wrapped in its own blanket-like tail.

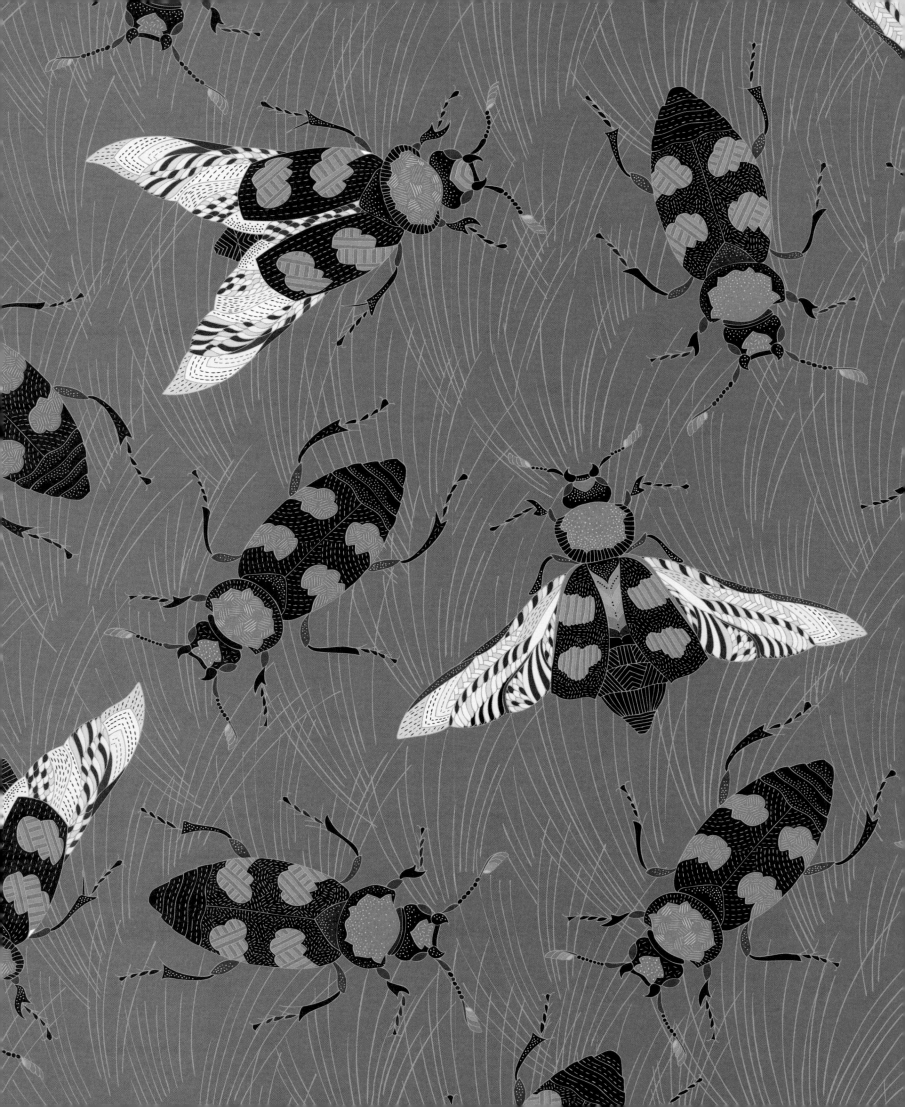

American Burying Beetle

The American burying beetle is a natural recycler, disposing of carcasses in tiny patches of America's Midwest and South and on Block Island, off the coast of Rhode Island. It sniffs out death's aroma on the breeze with its sensitive antennae and takes flight in search of its source. Perhaps it's a rodent, but other beetles have picked up the scent and an almighty battle begins, male against male, female against female. One couple triumphs, breeds and prepares gorily to raise their young.

They bury the carcass—no mean feat when your hoard is many times your size—scurrying beneath it, moving it with their legs, then digging furiously until it is entombed. Next, the beetles strip away its fur and cover the carcass in an antibacterial secretion to preserve it. The female lays her eggs in the earth around the body and when they hatch the parents tear off pieces of flesh and regurgitate it to feed their young. Within a week, only bones remain. Their work done, the parents scuttle to the surface and fly away, leaving their young to pupate. In just a month, they will emerge as adult beetles and restart the cycle.

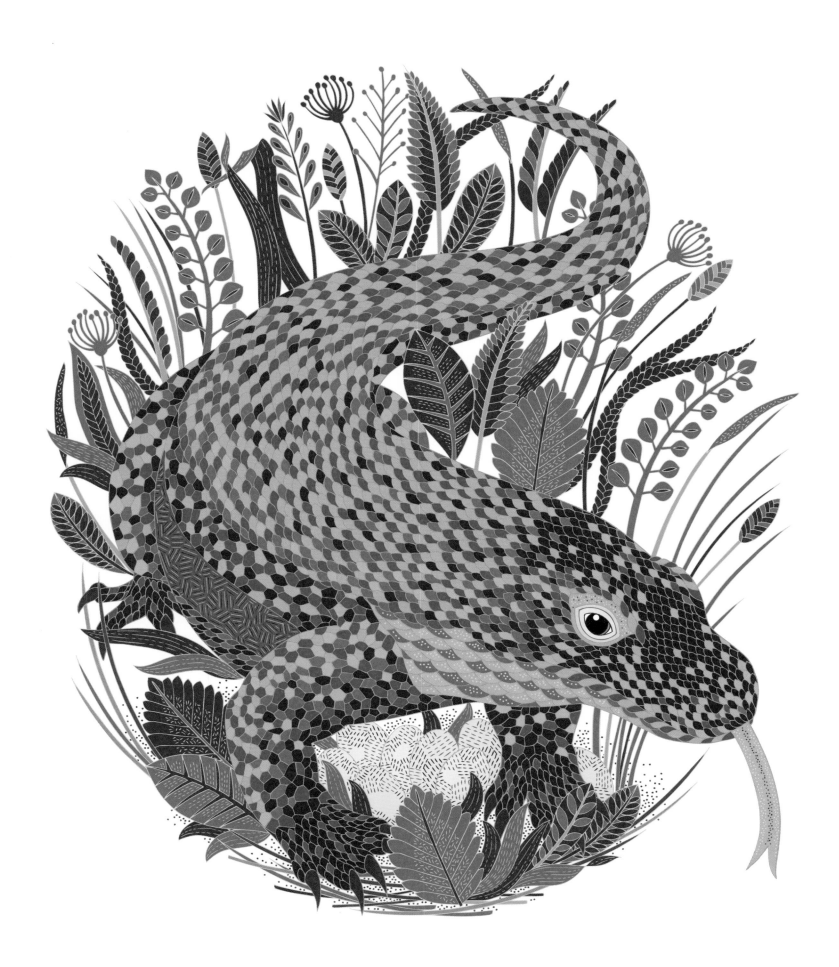

Komodo Dragon

On the Indonesian island of Komodo, a baby lizard emerges from its egg and scurries up the nearest tree; on the ground, it would be a tasty morsel for adult Komodo dragons. Safely above ground, this baby Komodo gorges on grasshoppers, crickets, beetles, geckos, and eggs, remaining there for four years: Only then is it large enough to survive at ground level.

These ferocious reptiles are the descendents of gargantuan lizards that lived 4 million years ago. At 10 ft long and weighing 150 lbs, the Komodo dragon is now the world's largest living lizard. It can bring down prey as big as a water buffalo with a deadly bite from its powerful jaws, and even if a victim escapes, it will succumb to the venom secreted in glands in the dragon's lower jaw and the dragon will seek out its corpse, from up to 5 miles away, with its remarkable sense of smell.

Recently, it was discovered that female Komodo dragons can reproduce without a mate. She will lay fifteen to thirty self-fertilized, grapefruit-sized eggs, all male. If a female ended up alone, she could restart the population, although mating with her offspring would not be good for the gene pool.

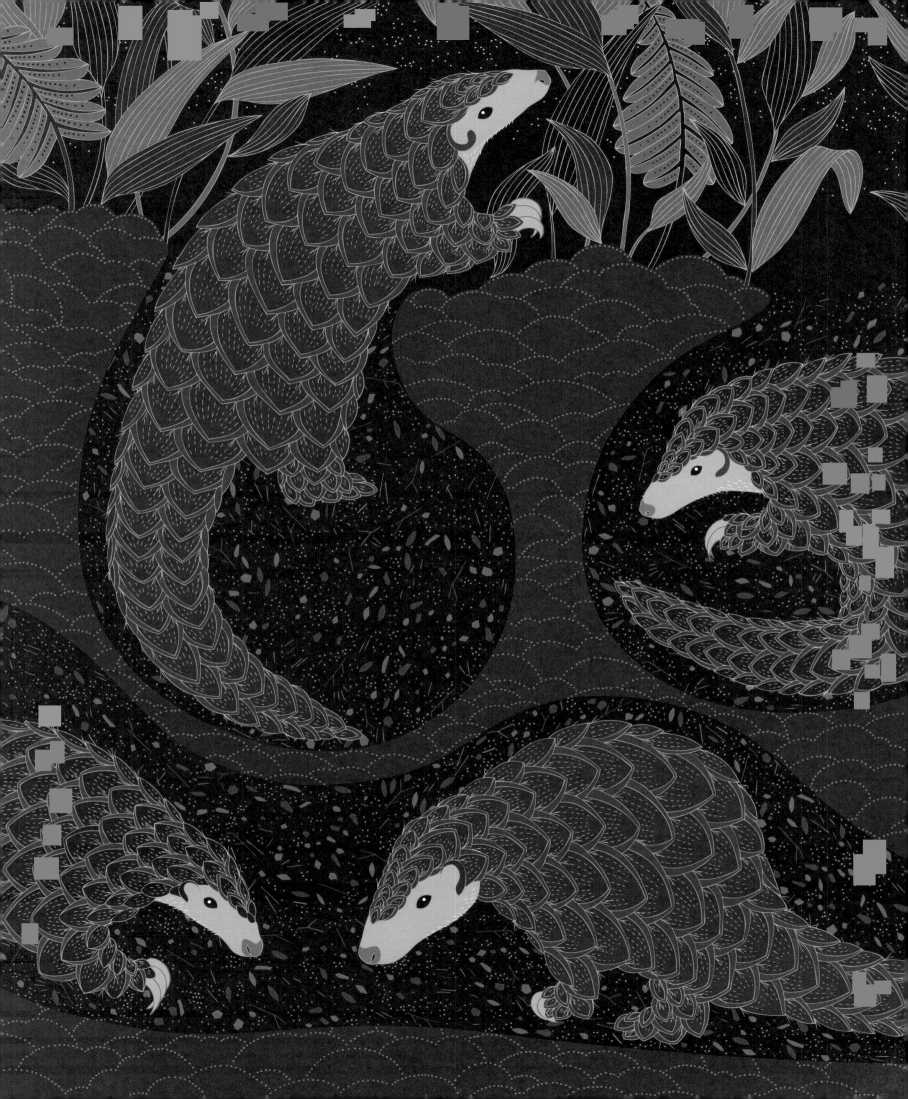

Pangolin

In the grasslands of southeast Asia, a strange creature the size of a domestic cat emerges from a deep burrow in search of its supper. Covered in hard scales but with a soft pink underbelly, beady little eyes, a long snout, and a strong, thick tail, it has a sticky tongue as long as its body to slurp up ants and termites. The Chinese pangolin looks like a walking pine cone—something from the pages of a fairy tale. Females give birth only once a year, to just one baby at a time, known as a pangopup.

There are eight species of pangolin and all of them are under threat. They are the world's only scaly mammal, and the most illegally trafficked animal on Earth; over 100,000 pangolins are caught by poachers every year across Asia and Africa—that's roughly one every five minutes. These mostly nocturnal creatures are sensitive little souls, making it difficult to care for those rescued. Sadly, the pangolin's defense is also its downfall. It curls up into a tight, scaly ball to protect itself, but this simply makes it easier for a pangolin poacher to scoop them up.

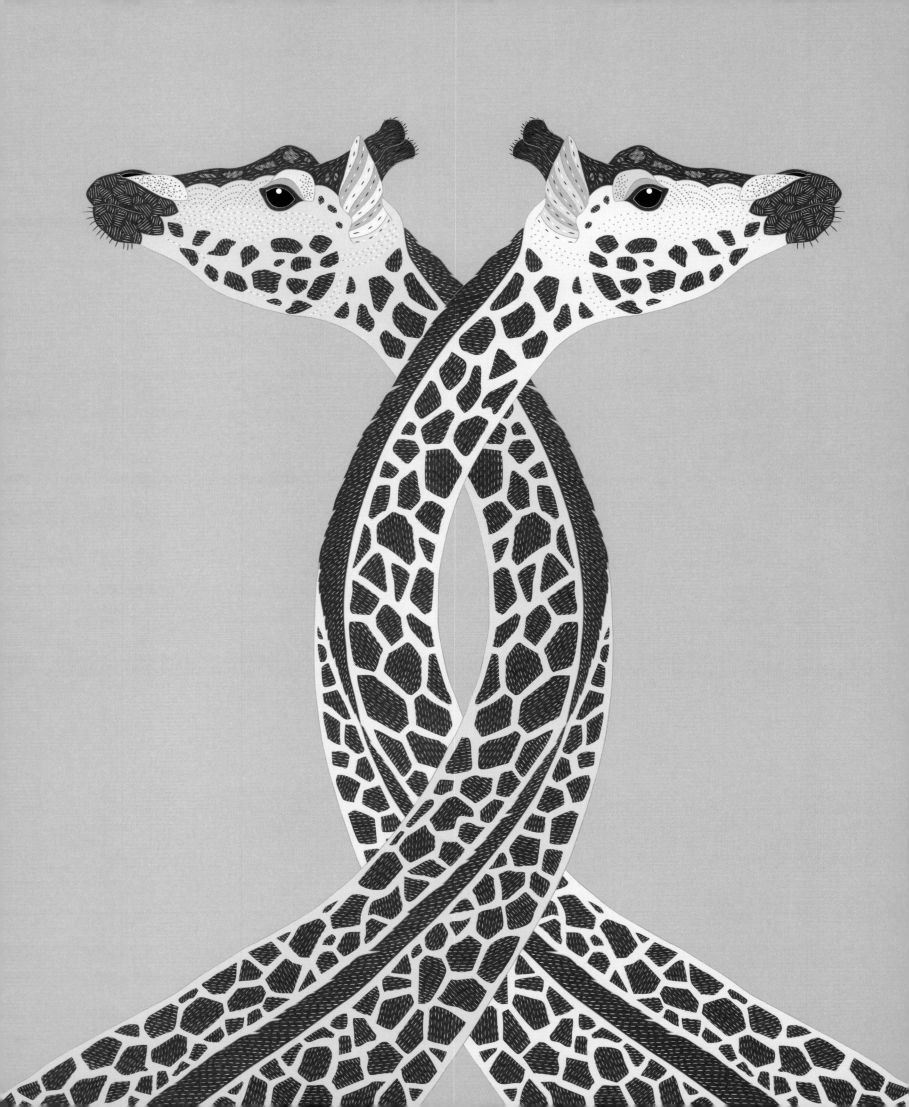

Giraffe

Giraffes make little noise, save for the bleating of their young, the odd grunt or snort, or the low nighttime humming only recently discovered by scientists. But a more troubling silence exists among giraffes: their disappearance.

We think of giraffes as part of the African backdrop, always there. Yet over the last thirty years, nearly 40 percent have been lost. But an exciting discovery could put the giraffe back in the spotlight: It appears there may be four distinct species rather than one.

Giraffes are largely regarded as peaceful and placid, gentle giants, but the males can be violent fighters, especially when they're in competition for a female.

But how do giraffes fight? A huge skull perched atop the world's longest neck makes for a deadly weapon. They spar, swinging their heads, each delivering crushing blows to the other's neck, underbelly, legs, and rump. These thundering swipes can send an opponent tumbling to the ground, sometimes knocking them unconscious and, on rare occasions, killing them. The giraffe left standing will stake his claim to the females, but the gracious victor, rather than chasing away his defeated foe, will invite him to live among the group.

— Mountains —

Found on every continent across the globe, mountains are formed by the movement of the Earth itself, and the habitat can change dramatically from season to season. What may be icy peaks during the harsh winter months can transform into green, flower-filled meadows during summer. Mountains can be permanently freezing, sun-scorched and craggy, grassy and windswept, or covered in lush tropical forests. Some have jungle at the base and a snow-capped peak; others lie on the ocean floor.

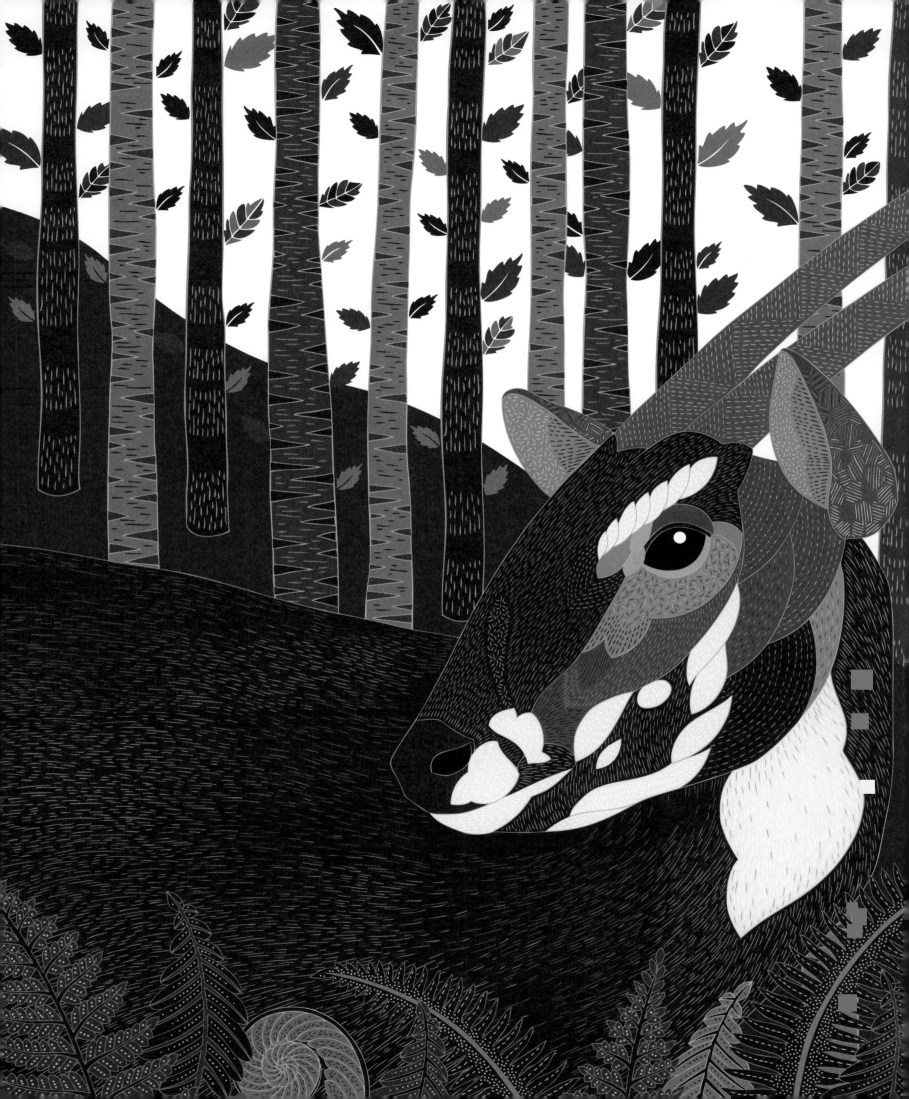

Saola

In 1992, biologists conducting a wildlife survey in Vietnam noticed a pair of pointed, gently curving horns hanging on the wall of a local hunter's house. The hunter said they had come from a mountain goat, but this was no goat. It was instead a creature so distinct from any other that it was given its own genus: It is the one and only species of saola and it was the first large mammal to be discovered in over fifty years. No biologist has ever seen a saola in the wild, and no one knows how many remain. At best there are a few hundred; at worse, perhaps just tens.

In 1996, the scientist William Robichaud spent three weeks with a female saola, Martha, whom local hunters had captured for a tribal leader's menagerie. He was captivated by her calm nature; within a couple of days, he could stroke her and she would even eat out of his hand. Sadly, just eighteen days later, Martha died, probably because of poor diet in captivity. After her death, it was found she had been pregnant, so the world lost two critically endangered saola that day. Every captive saola since has also perished.

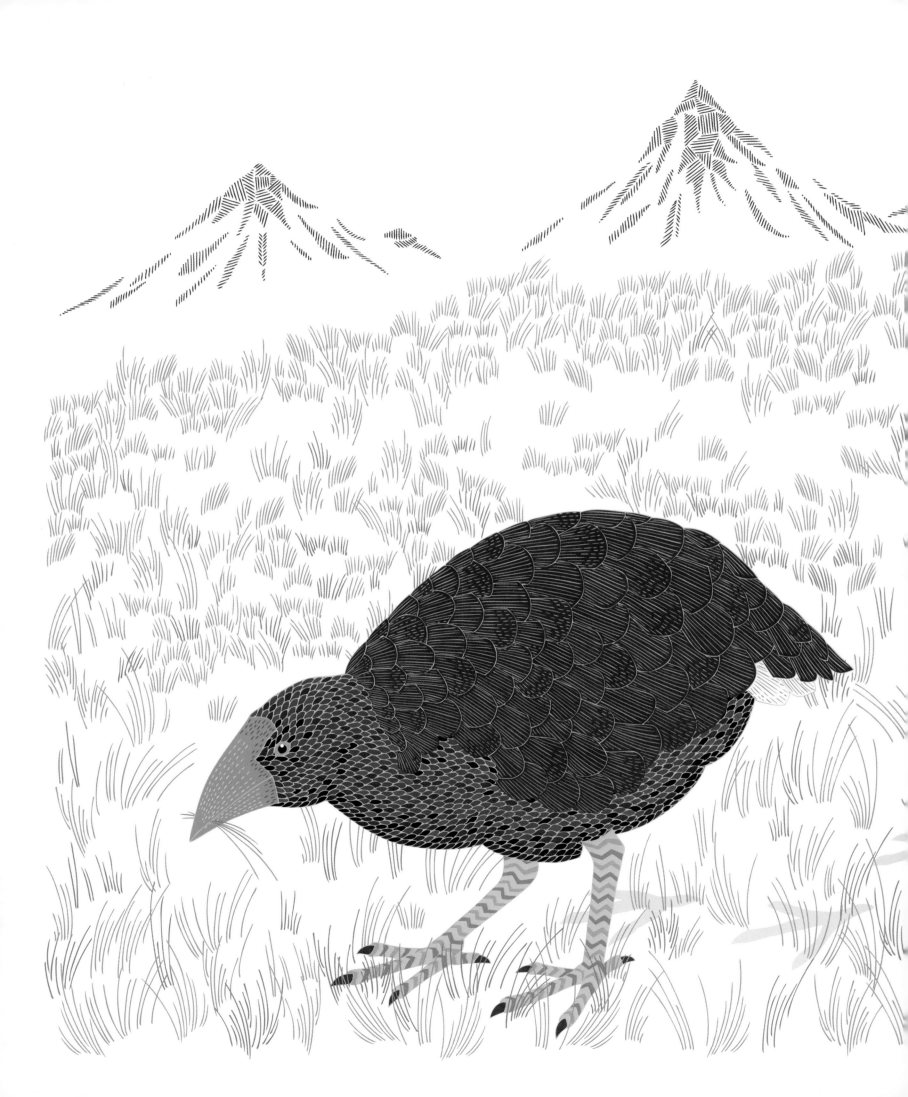

South Island Takahē

New Zealand is home to sixteen of the sixty or so species of flightless birds in the world. Because they lived on an island with no ground-dwelling predators to worry about, these birds didn't need to fly—a perfect example of "use it or lose it."

In 1898, the takahē was considered extinct. The arrival in New Zealand of humans, with their tag-along critters of rats, cats, mice, stoats, deer, sheep, and dogs had spelled disaster for the islands' flightless birds. But was it the end?

High up in the steep, snow-capped Murchison Mountains, in a crevice between the rocks, a chubby bird, about the size of a chicken, huddles over two eggs, keeping them warm. Nearby, another busily chops away at the tussock grass, its favorite food. The pair, with their peacock-blue and olive-green feathers and bright red beaks, look out of place against the washed-out colors of their bleak surroundings. For half a century, the takahē hid away, before its exciting rediscovery in 1948.

Since then, takahē have been bred in captivity and are being raised in predator-free sanctuaries; others have been released into the Murchison Mountains, with hopes to boost the wild population. But despite fifty years of efforts, the total population, both wild and captive, is currently around 375.

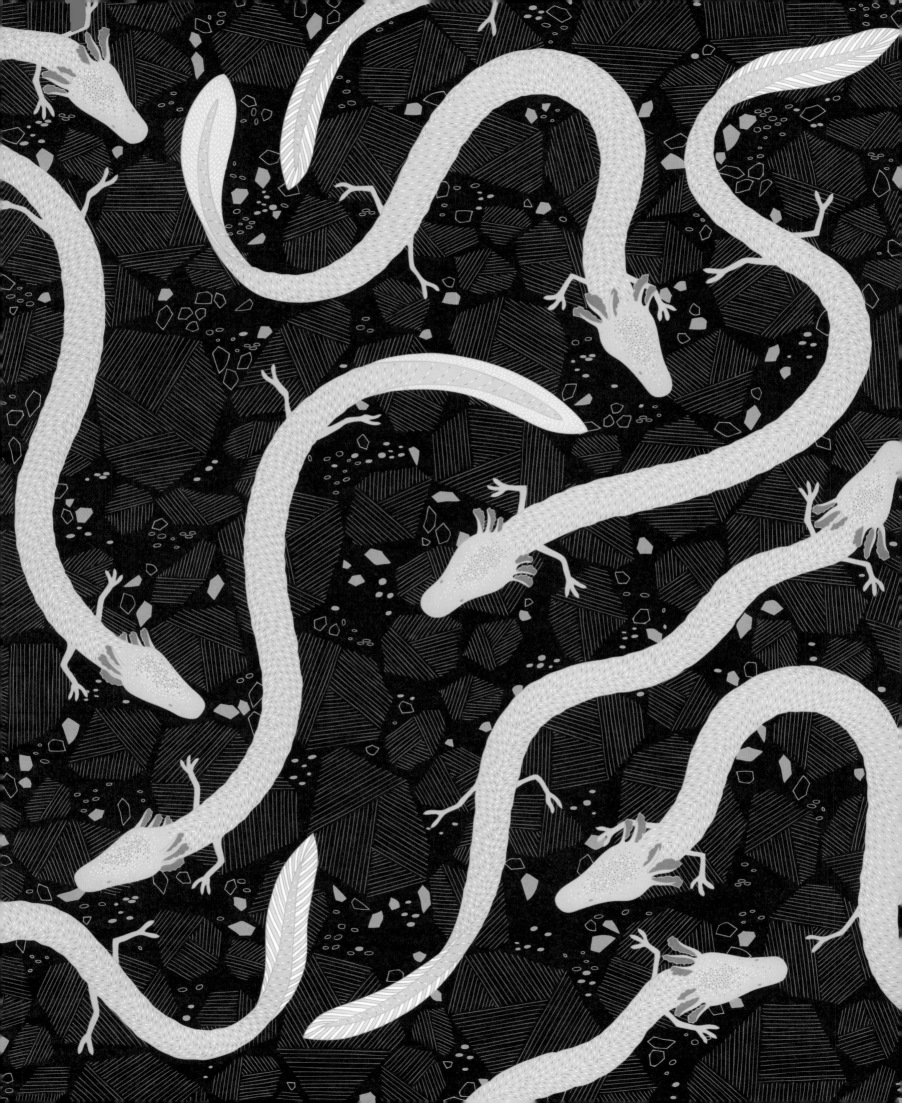

Olm

This otherworldly creature lives in sinkholes and caves deep beneath the Dinaric Alps—perfect hiding grounds for baby dragons, or so people thought in the past, when floods washed olms out from underground.

The olm spends its entire life under water and is brilliantly adapted to living in a world without light. Its skin has no pigment: The pale pink shade we see comes from blood vessels close to the surface of the skin. It swims around like an eel, its slinky body exaggerated by four tiny legs, and it is thought to use the Earth's magnetic field to navigate its way through the darkness. Olms are born with eyes, but with no need to see in the pitch-blackness a layer of skin grows over them. Instead of sight, it uses its hypersensitive senses to hear and smell its prey. It can even detect the weak electric-fields given off by crabs and snails using its electro-sensitive sixth sense.

Food can be scarce in underground caves, but the olm can fast for an unbelievable ten years. Perhaps even more impressive, this minuscule amphibian, only 12 in long and weighing less than an ounce when fully grown, can live up to one hundred years.

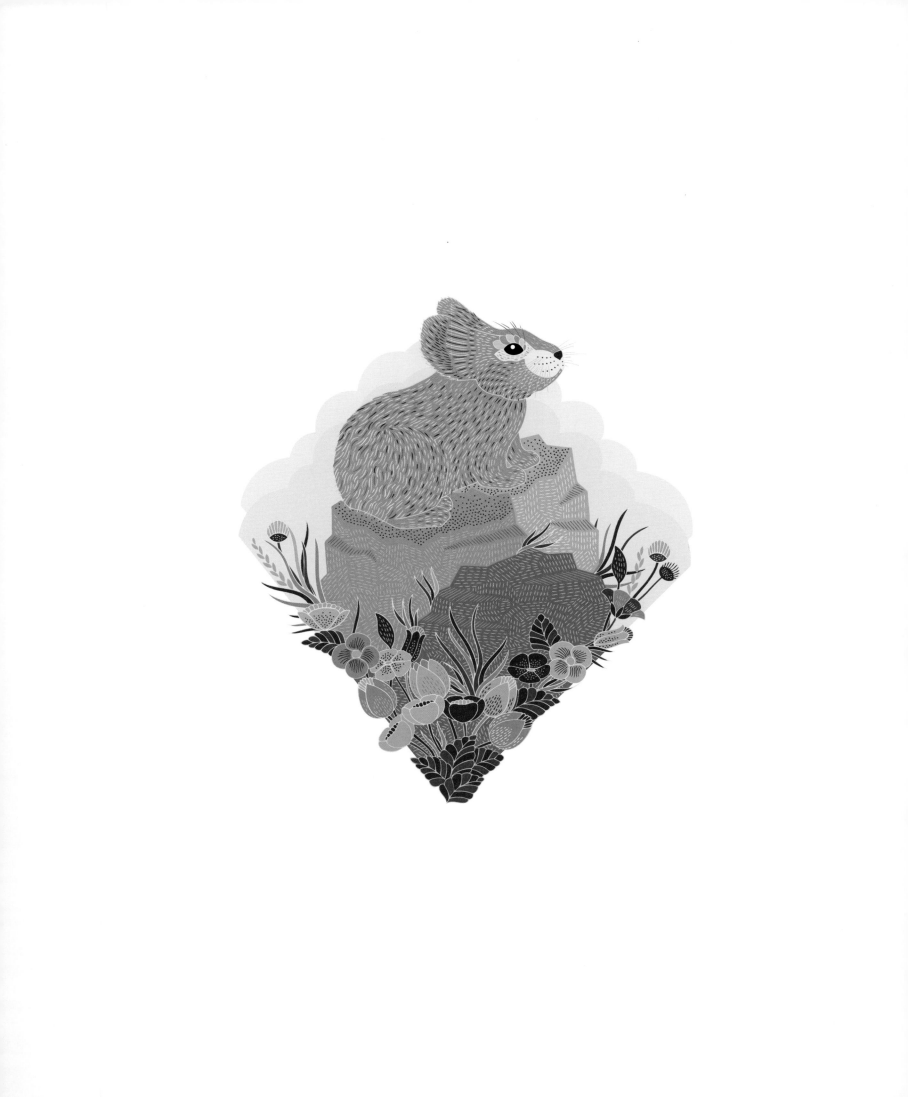

Ili Pika

The Tian Shan mountains of northwest China make an excellent hiding place. At freezing altitudes reaching 13,000 ft, not many humans go there, which is how a tiny mammal the size of a small guinea pig remained undiscovered until 1983, and then disappeared again. And so began a game of hide-and-seek that spanned decades.

The remarkably cute ili pika—nicknamed "magic bunny" in recognition of their closest relatives, rabbits and hares—was discovered, by chance, by a conservationist named Li Weidong, who was working in the mountains. Following a four-hour hike uphill, Li paused to catch his breath and was startled by a ball of fur darting past him. Curious, he sat and waited. Then a pair of fluffy ears popped up from a crack in the rocks, followed by an adorable face. Li was smitten, and over the next ten years he and the pikas played cat-and-mouse—Li always on the lookout, the pikas always giving him the slip. It was only in 2014 that Li ended this game of hide-and-seek and won the ultimate prize. A cheeky pika hopped out and jumped over his foot, and he photographed it: the first photo of an ili pika in over twenty years.

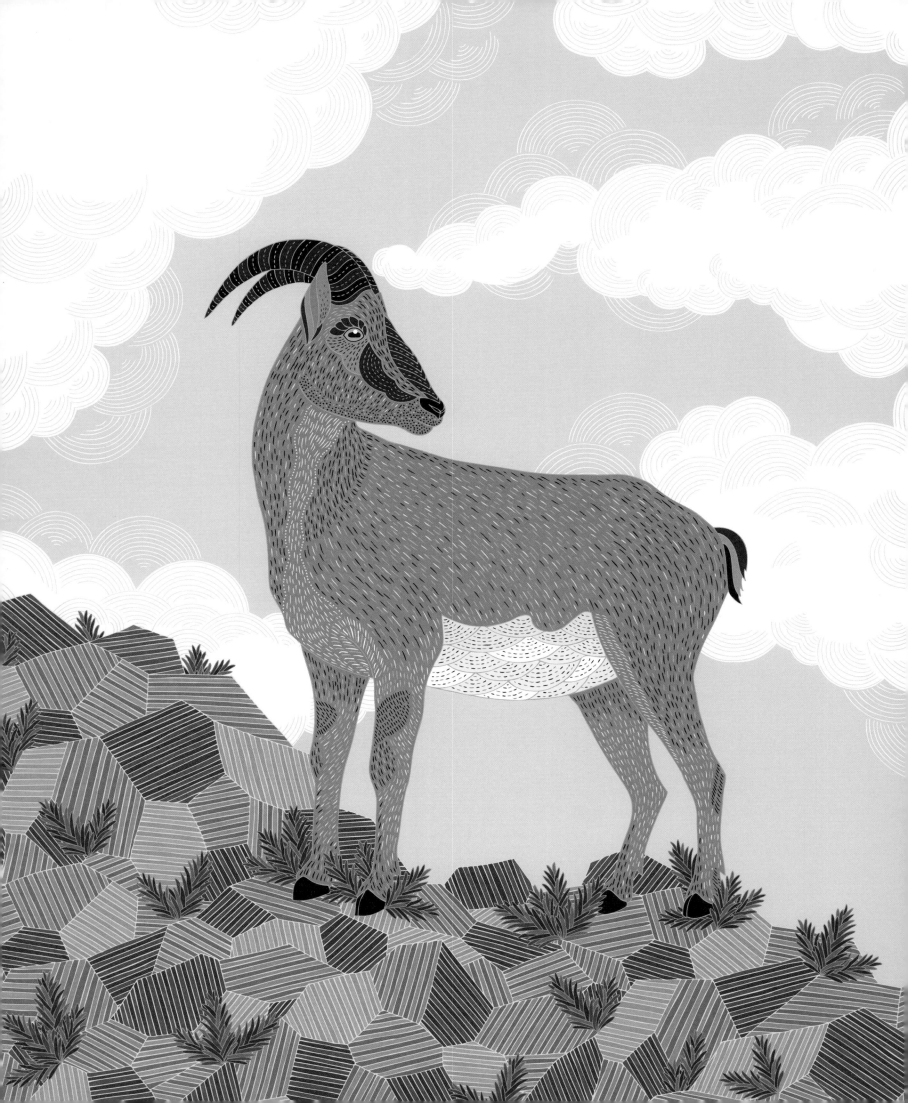

Nilgiri Tahr

Along India's western edge runs a chain of mountains called the Western Ghats, a once-rich patchwork of mountain forests and grasslands, and one of the most biodiverse regions on Earth. It is here, and only here, that you will find the Nilgiri tahr, the state animal of Tamil Nadu. It is protected by the Indian Wildlife Act, and reserves, protected areas, and sanctuaries provide safe havens, but even so only 3,000 survive today. Standing 3 ft tall, with horns that can reach 16 in, the Nilgiri tahr is a powerful beast. But is it a goat, an antelope, or a sheep? Well, you could call it a goat-antelope.

For most of the year, males live alone, flitting between female herds or forming small bachelor groups, while females stick together in herds with their young, in monsoon season gathering in larger groups to mate. Courting is a serious affair and a male goes to great lengths to impress. First, he drenches himself in his own urine, rich with scents that will attract females; then he adorns his impressive horns with a crown of earth and grasses.

But if another male has eyes for the same female, they must settle the score by battling. Fights can last for hours but eventually one will give in. The winner, looking sharp and smelling fine, is ready for courtship.

— Tundra —

Tundras are vast, treeless areas, cold and dry, with bitter winds that whip across the landscape. Most of the Earth's tundra is found in the Arctic Circle, but there are also areas in Antarctica, and in high mountain ranges across the globe there is alpine tundra. Often snow-covered, in summer the Arctic meltwaters create giant marshes, attracting migratory birds; in the alpine tundra, grasses and small shrubs germinate, grow, and flower swiftly, to complete their lifecycle within just fifty to sixty days.

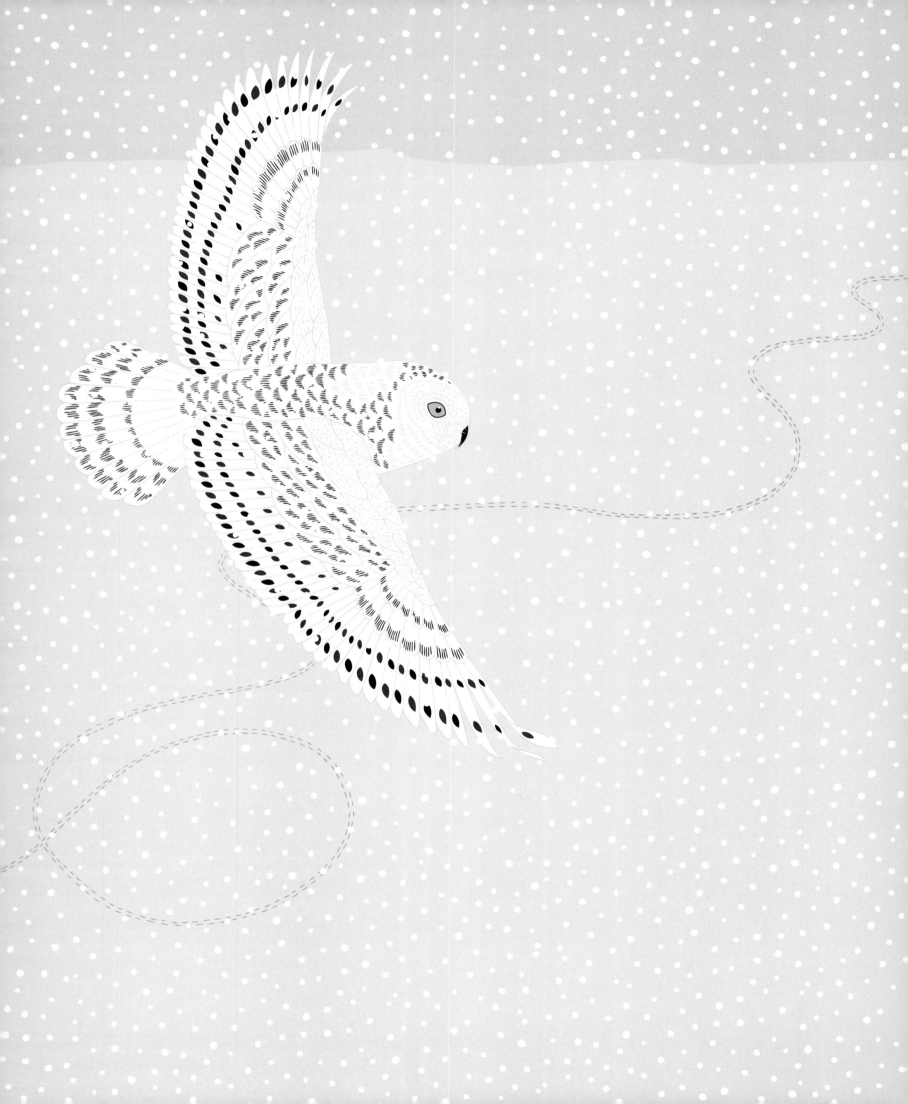

Snowy Owl

The magnificent snowy owl spends most of its life north of the Arctic Circle, where it roams across the tundra, hunting for its favorite meal, lemmings. During Arctic summers, the sun never sets, so the snowy owl, unlike most owls, hunts by daylight.

These incredible birds locate particular areas where lemming populations thrive and go in pursuit, changing their nest site every year to be near them, an unusual behavior for birds. Lemmings not only provide food but somehow (we don't yet know why), they also trigger breeding in the snowy owl. The number of eggs laid depends on the amount of lemmings: If lemmings are in short supply, the owls may not breed at all, even if other food is available. In a bumper lemming year, one owl might lay up to eleven eggs. That's a lot of hungry beaks to feed, so the harvest begins, the male snowy owl silently collecting lemming after lemming for his ravenous gray fluffy chicks.

But climate change brings springtime to the Arctic earlier each year, so what normally falls as powdery snow is wetter, often turning hard and icy. This makes it difficult for lemmings to forage for food and this, in turn, affects the number of snowy owls born.

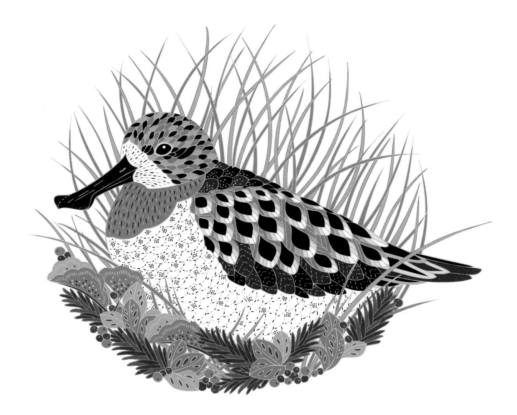

Spoon-billed Sandpiper

The spoon-billed sandpiper is a pip-squeak of a bird, only 5 to 6 in long, with beady black eyes, smooth feathers, and a spatula-shaped bill unique among the world's waders and perfect for sieving small invertebrates out of the mud.

It breeds in one of the most remote places on Earth, the Chukotka peninsula, a headland of freezing coastal tundra in eastern Russia where fearsome predators, Arctic temperatures, snow, and floods threaten the birds and their young. This little powerhouse of a bird then has to reach its wintering grounds, the steamy, tropical mudflats of Southeast Asia, and then come back to Chukotka again, to its summer breeding grounds—an incredible round trip of 10,000 miles, on such tiny wings!

Few birds have hurtled as quickly toward extinction as the little-known spoon-billed sandpiper, as the rest stops it needs on its long journey are destroyed and polluted. But for the first time, a pair of adults in the wild has been filmed incubating and brooding their young, and the chicks themselves emerging from the nest. Perhaps these tiny puffs of speckled feathers, hardly bigger than large bumblebees, will become the poster children the species desperately needs.

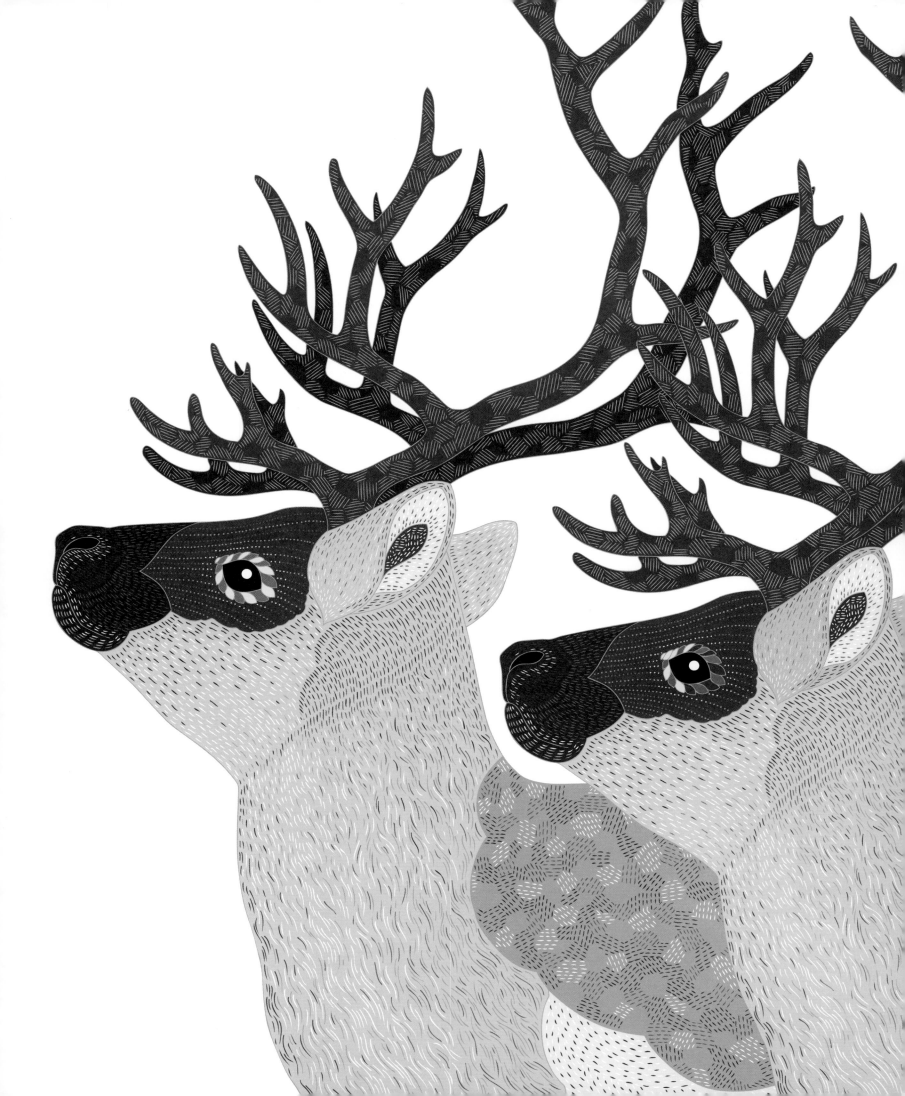

Caribou

Caribou, or reindeer, migrate north every summer to feed, on paths used for generations. Even summer temperatures are freezing where the caribou makes its home, but it is well prepared.

Its large hooves serve as brilliant snowshoes, as paddles for crossing rivers, and as snowplows to scoop away snow when foraging. A foot joint clicks when it walks, keeping herds together when visibility is poor, and its coat has a warm underlayer and an outer, insulating one. To cope with the dark winter months, the backs of their eyeballs change from gold in the summer to blue in the winter, reflecting less light away from the eye, and the network of blood vessels in their velvety noses warms the air before it reaches their lungs.

A migrating herd may number thousands, a huge mass moving across the land. With global warming, longer summers mean more grass; the herd packs on the pounds and the females carry more than one calf. But then warmer winters bring rain rather than snow, which freezes and forms a barrier to the juicy grasses and plants below. The females cannot eat enough and many babies do not survive; those that do are much smaller and would find it hard to pull Santa's sleigh.

— 87 —

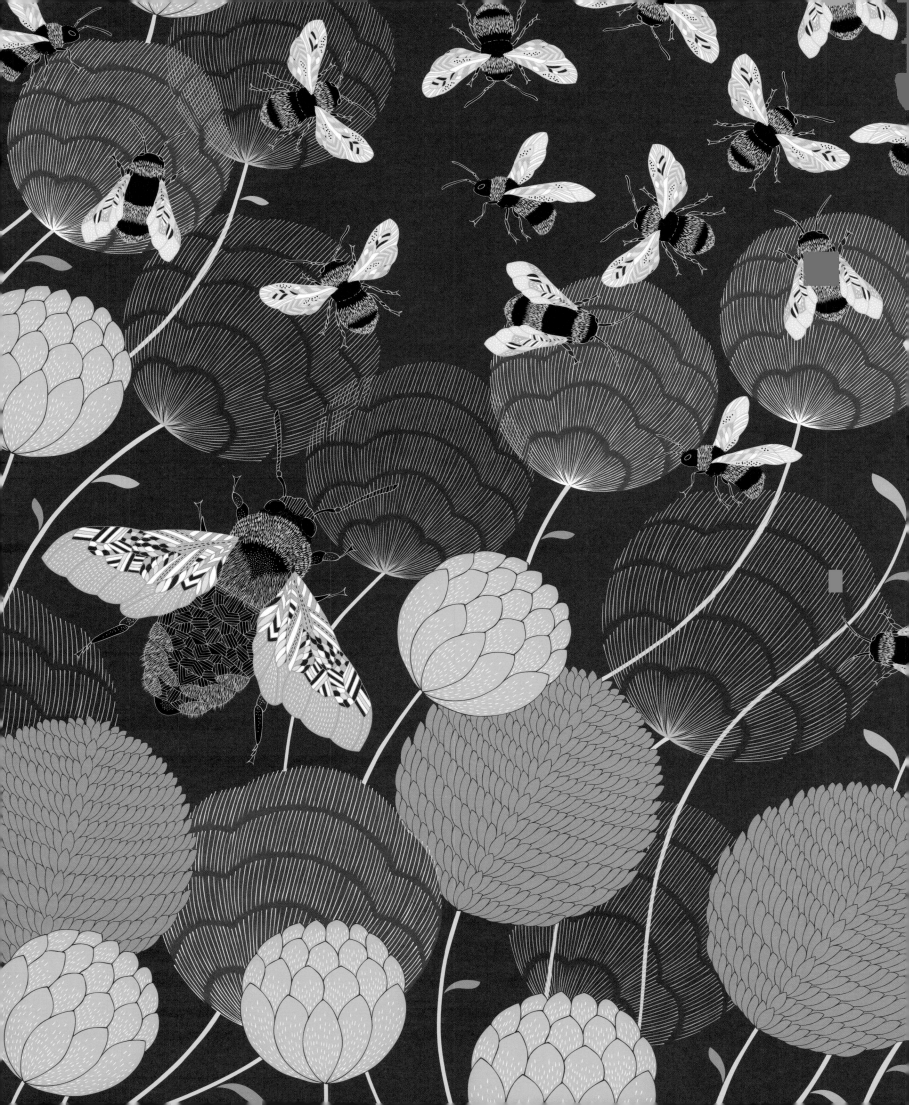

Suckley Cuckoo Bumble Bee

"Busy bee," "little worker bee"—there are many terms for these hard working, pollinating insects. But not all bumblebees are team players. The Suckley cuckoo bumble bee doesn't model its behavior on that of its fellow bees; instead, it copies the cuckoo, a sneaky con artist happy to sit back and let someone else do all the hard work. Why bother to build a nest when you can steal someone else's? Why rear your own young when somewhere there's a colony of willing babysitters?

This bee has truly mastered the art of taking advantage. First, the female bee must choose her colony wisely: big enough to supply ample babysitters but not so big that the worker bees might overpower and defeat her. She scopes out her target, taking on its scent to help her infiltrate the hive. Moving in, she quickly finds the queen, whom she closely resembles (and any small differences go unnoticed by the busy hive). Then she kills or subdues the queen and sets about laying her own eggs to be raised by the unsuspecting worker bees.

Cheats they may be, but cuckoo bees are also pollinators. In a world that depends on the pollination of plants for food, every pollinator counts, even the sneaky imposters.

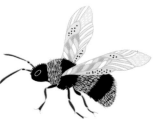

— Wetlands —

Swamps, marshes, fens, bogs, mangroves, estuaries, mudflats, deltas, and floodplains—wetlands can be saltwater, freshwater, or a mixture of the two, and they usually contain many plants. Some are permanent, while others exist only for a time after floods or heavy rain, and they are often dotted with small areas of land, islands, and banks rising just above the surface. Wetlands can be vast, covering tens of thousands of square miles, or no bigger than a garden pond.

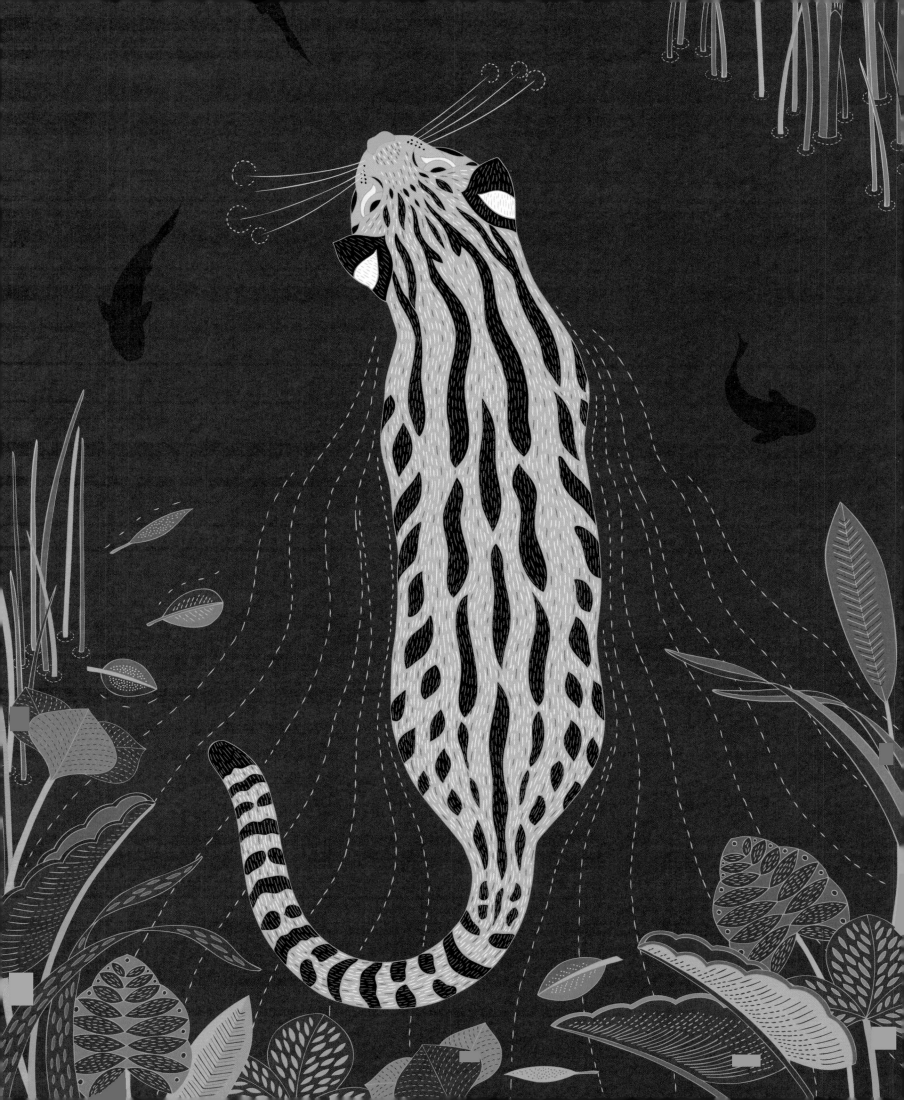

Fishing Cat

Deep within the dense vegetation of Sri Lanka's wetlands, a fisherman crouches motionless on a rock ledge, poised and ready to strike. These felines don't mind getting their paws wet. It looks like a domestic cat, but it is 3 ft long, can weigh up to 36 lbs, and is semi-aquatic. Two layers of fur provide excellent waterproofing, with long, coarse hair that keeps the water out and fine fur below that insulates against the cold and wet; their ears fold back flat when diving; and their claws, which do not fully retract, make perfect tools for hooking fish.

Meanwhile, in the residential areas of Sri Lanka's capital city, Colombo, urban fishing cats cross roads and scale garden walls in search of tasty koi kept as pets in garden ponds.

And it is not just fish that the cats have a taste for. They also find livestock such as chickens and ducks irresistible, but such tastes lead humans to retaliate. Unlike its cousins the lions, tigers, and leopards, this charismatic feline is not very well-known, and so its plight goes unnoticed, while it waits for its time in the spotlight.

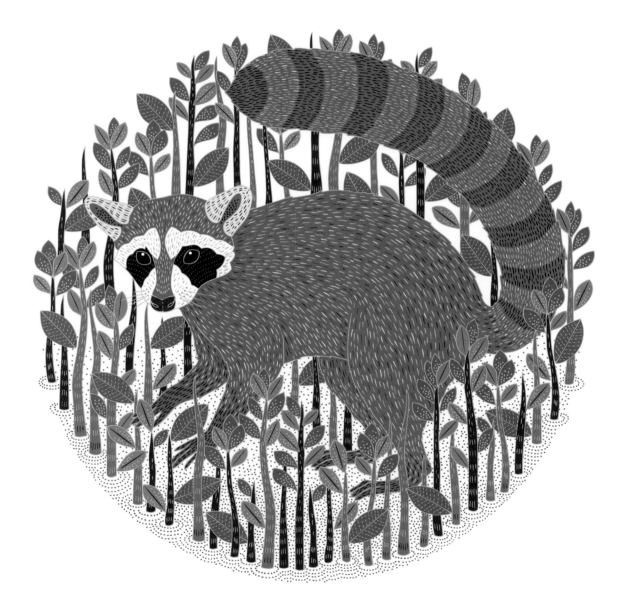

Pygmy Raccoon

Pygmy raccoons are outgoing, cheeky, and opportunistic. They are natural hunters, easily catching crab, crayfish, and frogs, but now they have found a new source of food.

As families picnic on the northern tip of Cozumel Island—9 miles off the Yucatán peninsula in Mexico—tiny paws scrabble through the undergrowth and big black eyes ogle their tasty snacks. And then, shamelessly, a pygmy raccoon steps up and starts begging, grabbing whatever tidbits the charmed humans present.

Picnicking with pygmies: What could be more delightful? But as well as concerns for the raccoon's waistline, the danger is that they gather where humans are, rather than spreading out across their natural habitats, and this means there is a risk of inbreeding.

Pygmy raccoons, despite their bandit masks, don't share their North American cousin's reputation as menacing little outlaws; in fact, they are a completely separate species. Found only on this tiny island, they are one of the world's rarest carnivores. It is thought they were isolated from their cousins when the island separated from the mainland over 100,000 years ago, and they have evolved to be much smaller. These pint-sized critters are now about half their original size.

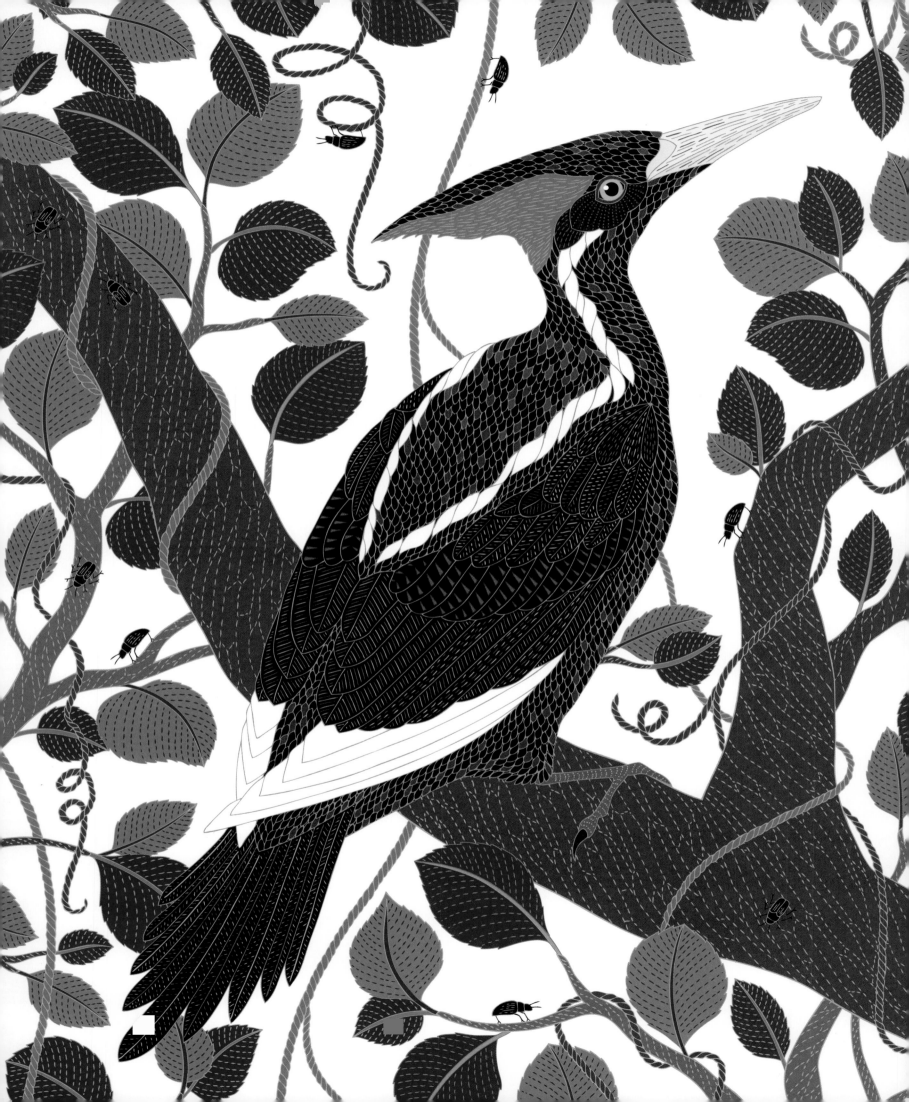

Ivory-Billed Woodpecker

It's difficult to know when a species is truly extinct, but both the South Island takahē and the Chacoan peccary have seemingly come back from the dead. Could it be that the ivory-billed woodpecker, last seen in the lowland swamp forests of Arkansas sixty years ago, is another such secret survivor?

Dubbed the "Good God" bird, after people's response to its eye-catching feathers, bright red crest (on males), and large white bill, it is the third-largest woodpecker in the world. Their bills, made not of ivory but of bone and keratin (like our fingernails), were prized by some Native Americans and have been unearthed far from the birds' old habitat, used perhaps as trading items.

An image captured on video in 2005 convinced many that the ivory-billed woodpecker is back from oblivion. Aboard a kayak drifting silently through the water, a team of biologists are eager to prove that somewhere in the vast expanse of the swamp an ivory-billed woodpecker is at large. From the distance comes a telltale tap-tap, then a bird call, typical of the species: toot, toot—like a tiny trumpet or the horn of a toy car. And then, a flicker of black and white and a bold flash of red.

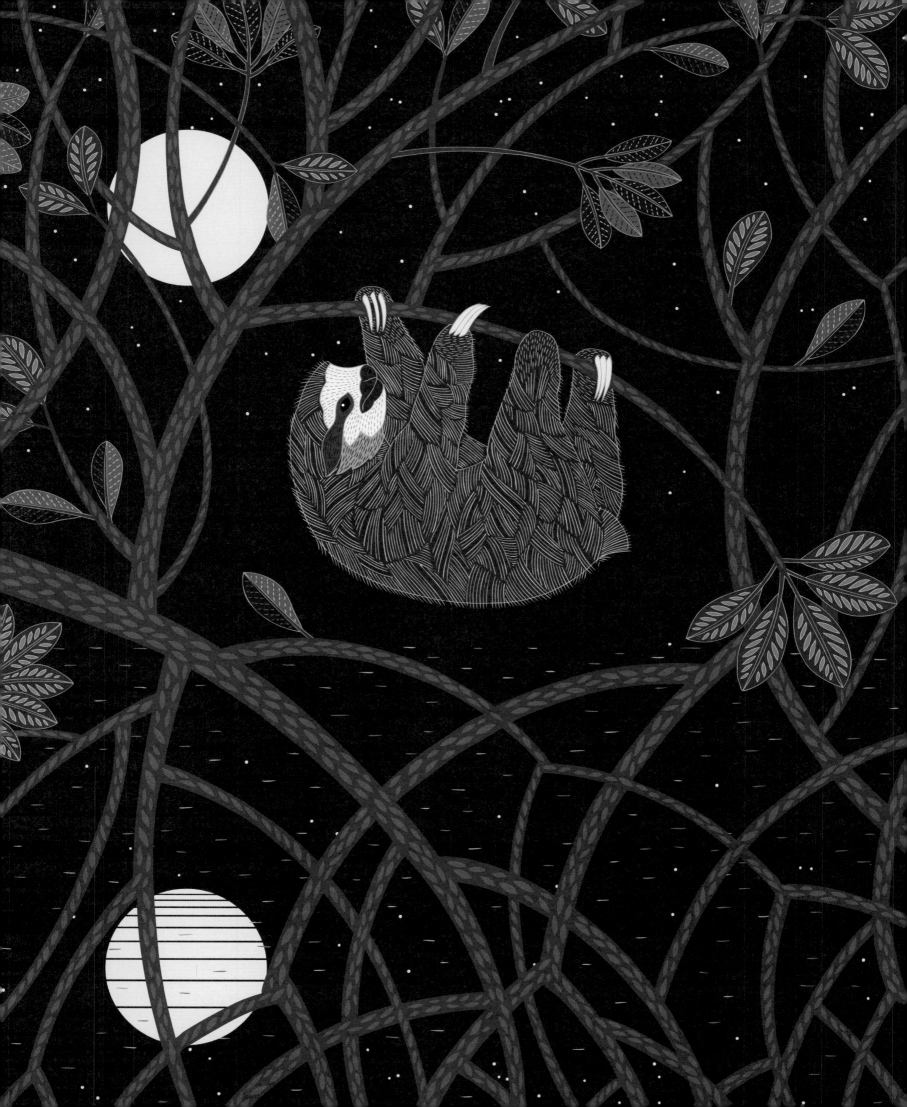

Pygmy Three-Toed Sloth

Sloths are famous for being slow. Indeed, they move so slowly that green algae grows on their fur. Perhaps not very attractive, but it helps camouflage them among the leafy canopies they call home. Their lack of speed also protects them from harm: Natural predators are attracted to movement, so sloths go undetected.

Pygmy three-toed sloths live only on Isla Escudo de Veraguas, a tiny Caribbean island uninhabited by humans. Nearly 9,000 years ago, the island separated from the mainland and the sloths were marooned. To survive on such a tiny landmass, they shrank by 40 percent and grew even slower, perhaps because, unlike the mainland sloths, they eat only mangrove leaves, nutritionally poor and low in calories.

These laid-back charmers hang out in trees but are surprisingly good swimmers, thanks to their bloated, gassy bellies, full of fermenting mangrove leaves, keeping them nicely afloat while they bob along doing the doggy-paddle, moving faster in the water than they do on land.

But life for this happy-go-lucky Caribbean islander is no longer paradise. There are six different species of sloth in the world, and the pygmy three-toed variety is the most endangered of all.

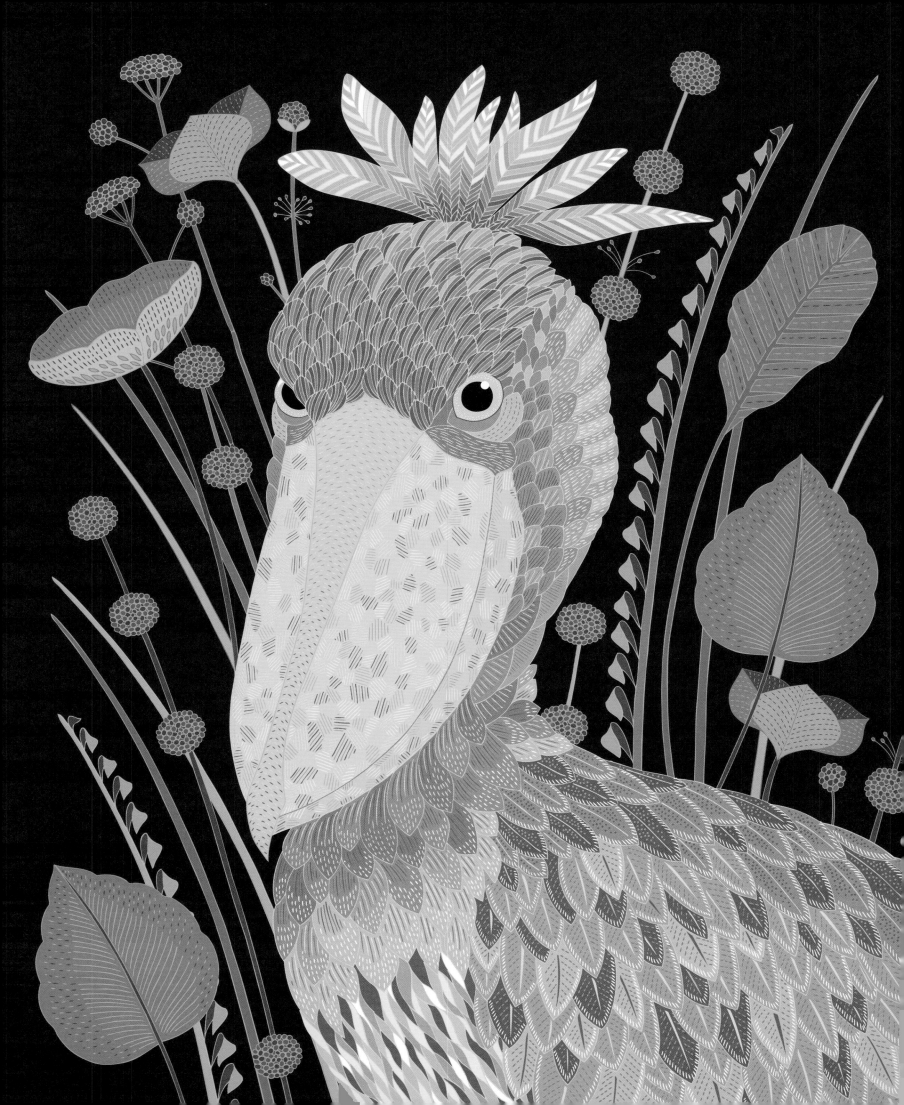

Shoebill

Looking for a connection between birds and dinosaurs? Try the gargantuan shoebill. Standing up to 4.5 ft tall, this is one terrific bird. Its huge bill—9 in long, 4 in wide—is fixed in a menacing grin and tapers to a viciously sharp hook. It waits in ambush in tropical swamps and marshes, on the lookout for catfish, eels, snakes, even baby crocdiles— and its favorite, the delicious-sounding lungfish. It stares, gray eyelids blinking slowly. Suddenly it lunges, snapping up its supper, and that formidable hook decapitates its prey. Solitary and often silent—the clattering of its bill sounds much like machine gun-fire—this sinister bird will even turn on a weaker sibling, pecking at it until it is driven from the nest.

But for all its terrifying qualities, the shoebill deserves our support. And, in some ways, it is quite endearing. Its beak is terrifying but so cumbersome that young chicks are top-heavy and topple over with the weight of it. A comedy sprout of feathers atop their heads wiggles whenever they clack their bill. And that stare— so intense, but not entirely without mischief. Once you've noticed these things, it's difficult to see the shoebill as some kind of feathered monster.

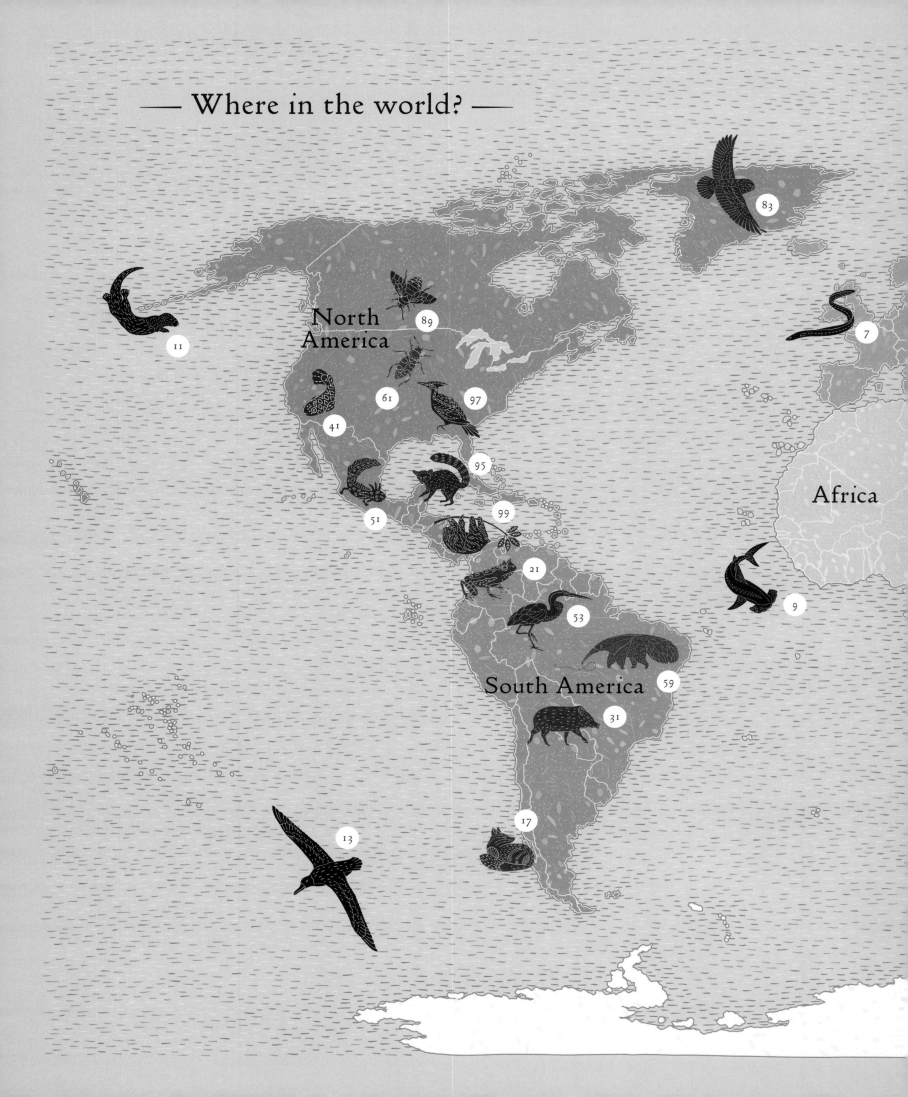

Where in the world?

North
America

South America

Africa

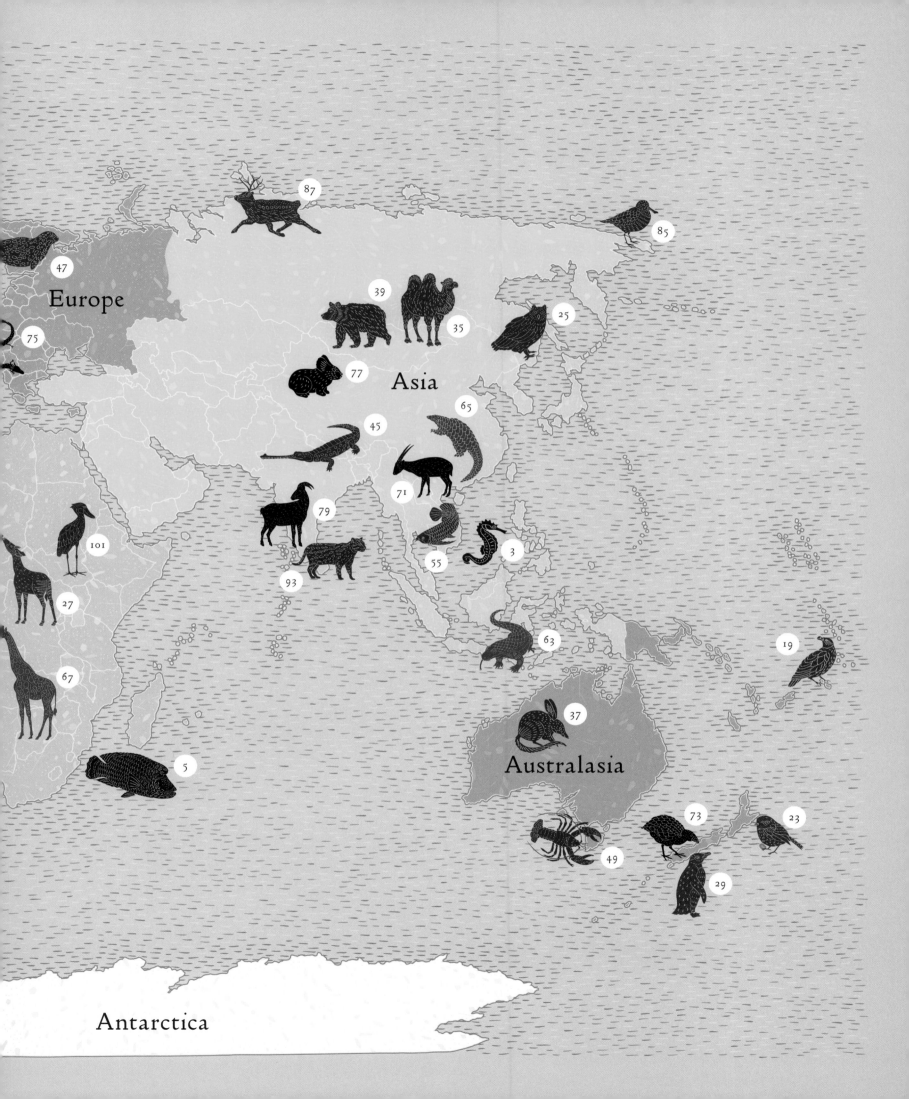

Europe

47

75

Asia

87

85

39

35

25

77

65

45

71

79

101

27

55

3

93

67

63

5

19

37

Australasia

73

23

49

29

Antarctica

What are the threats?

All the animals in this book are considered "threatened" by the International Union for Conservation of Nature (IUCN) and are at risk of extinction in the near future. They each fall into one of the following three categories on the IUCN Red List of Threatened Species™, the world's most comprehensive inventory of the global conservation status of plant and animal species:

VU - Vulnerable - Facing a high risk of extinction in the wild
EN - Endangered - Facing a very high risk of extinction in the wild
CR - Critically Endangered - Facing an extremely high risk of extinction in the wild

Oceans

Tiger tail seahorse (p. 3)
Hippocampus comes
Status: VU
Number of mature individuals: Unknown
Where in the world: Southeast Asia
Threats: Humans harvest tiger tail seahorses to use in traditional medicine, as pets, and as gruesome souvenirs. Habitat destruction and getting caught in nets intended for other species are also serious threats.

——

Humphead wrasse (p. 5)
Cheilinus undulates
Status: EN
Number of mature individuals: Unknown
Where in the world: Indian Ocean, Pacific Ocean
Threats: The humphead wrasse is extremely vulnerable to poaching as it's one of the most expensive fish in the live reef-fish trade.

——

European eel (p. 7)
Anguilla Anguilla
Status: CR
Number of mature individuals: Unknown
Where in the world: Europe, North Africa
Threats: Manmade barriers in waterways, pollution, overfishing, and illegal trade are all to blame for the eel's shrinking population.

——

Scalloped hammerhead shark (p. 9)
Sphyrna lewini
Status: EN
Number of mature individuals: Unknown
Where in the world: Western and Eastern Atlantic, Indian Ocean, Western and Eastern Pacific
Threats: The scalloped hammerhead's main threat is overfishing; their fins are highly prized for making shark-fin soup. They also get caught up in commercial fishing nets intended for other species.

——

Sea otter (p. 11)
Enhydra lutris
Status: EN
Number of mature individuals: Unknown
Where in the world: Canada, Russian Federation, Japan, Mexico, United States
Threats: Oil spills are the sea otter's greatest threat, but other dangers include climate change, disease, and a new predator, killer whales.

——

Wandering albatross (p. 13)
Diomedea exulans
Status: VU
Number of mature individuals: 20,100
Where in the world: Southern Ocean
Threats: Thousands of wandering albatross die each year when they are caught accidently, victims of long-line fishing. Other dangers include pollution, climate change, and invasive species such as cats, who prey on chicks.

Forests

Darwin's fox (p. 17)
Lycalopex fulvipes
Status: EN
Number of mature individuals: Estimated 659–2,499
Where in the world: Chile
Threats: Attacks by domestic dogs and the diseases they carry are the fox's main threats. Loss of habitat, hunting, and trapping are also serious dangers.

——

Little dodo bird (p. 19)
Didunculus strigirostris
Status: CR
Number of mature individuals: 50–249
Where in the world: Samoa
Threats: Hunting is a big worry as the little dodo bird is often mistaken for a similar-looking bird and caught by accident. Attacks by feral cats and rats along with climate change also pose a threat.

——

Horned marsupial frog (p. 21)
Gastrotheca cornuta
Status: EN
Number of mature individuals: Unknown
Where in the world: Central and South America
Threats: A deadly disease called *chytridiomycosis* is a massive threat to the horned marsupial tree frog. Other dangers include deforestation and pollution.

——

Black robin (p. 23)
Petroica traversi
Status: EN
Number of mature individuals: 230
Where in the world: New Zealand
Threats: Climate change and severe weather events are serious threats for the black robin's tiny population. In the future, any new diseases could also pose a huge problem for such an inbred species.

——

Blakiston's fish owl (p. 25)
Bubo blakistoni
Status: EN
Number of mature individuals: 1,000–2,499
Where in the world: Russian Federation, China, Japan
Threats: Habitat destruction is a major threat for the owl. Overfishing of its food source, pollution, hunting and trapping, collisions with power lines, and getting caught in fishing nets are also to blame for the shrinking population.

——

Okapi (p. 27)
Okapia johnstoni
Status: EN
Number of mature individuals: Unknown
Where in the world: Democratic Republic of the Congo
Threats: The okapi's major threats are habitat loss and illegal armed groups who have prevented important conservation work taking place. The okapi is hunted for its meat and skin but also gets caught in traps intended for other animals.

——

Yellow-eyed penguin (p. 29)
Megadyptes antipodes
Status: EN
Number of mature individuals: 2,528–3,480
Where in the world: New Zealand
Threats: On land, predators such as stoats, ferrets, and cats are a threat to the yellow-eyed penguin, as is disease. In the water the biggest danger is getting caught in commercial fishing nets. Climate change and human disturbance also pose dangers.

——

Chacoan peccary (p. 31)
Catagonus wagneri
Status: EN
Number of mature individuals: Unknown
Where in the world: South America (Argentina, Bolivia, Paraguay)
Threats: Habitat destruction has become a major threat to the Chacoan peccary. Other dangers they face are uncontrolled hunting by humans and disease.

Deserts

Wild Bactrian camel (p. 35)
Camelus ferus
Status: CR
Number of mature individuals: 950
Where in the world: China, Mongolia
Threats: Targeted by hunters for meat and sport, wild Bactrian camels also compete with domestic livestock for food and water. Habitat loss and highly toxic illegal mining pose further threats to this unique camel's survival.

——

Greater bilby (p. 37)
Macrotis lagotis
Status: VU
Number of mature individuals: 9,000
Where in the world: Australia
Threats: The biggest threat facing the bilby is being hunted by non-native predators: feral cats and foxes. In some areas its habitat and burrows are being destroyed by herds of farming animals, who also compete with the bilby for food.

——

Gobi bear (p. 39)
Ursus arctos gobiensis
Status: CR
Number of individuals: 25–40
Where in the world: Mongolia
Threats: Such a low population makes the Gobi bear very vulnerable to environmental changes and disease: the smallest of events could spell disaster. Drought and the disappearance of water sources in the desert are also very serious dangers.

——

Devils Hole pupfish (p. 41)
Cyprinodon diabolis
Status: CR
Number of individuals: Less than 200
Where in the world: Nevada
Threats: Devils Hole pupfish are vulnerable to even tiny changes in the level and quality of the water in their pool—lowered water levels could easily spell extinction—so water loss is a huge threat. They are also victims of vandalism, despite the pool being fenced off for protection.

Fresh Water

Gharial (p. 45)
Gavialis gangeticus
Status: CR
Number of mature individuals: 650–700
Where in the world: India, Nepal
Threats: Hunting used to be the gharial's main threat, and while this still happens—often just for body parts, which are used in traditional medicine—habitat destruction is now their major threat. Many also get caught up in fishing nets, and sometimes their eggs are collected for eating.

——

Saimaa ringed seal (p. 47)
Pusa hispida ssp. Saimensis
Status: EN
Number of mature individuals: 135–190
Where in the world: Finland
Threats: Climate change has affected snowfall, which is a major threat to these seals, who rely on plenty of snow for building dens to protect their pups. A number are also lost each year when caught accidentally in fishing nets, and pollution and human disturbance also put the seals at risk.

——

Tasmanian giant freshwater lobster (p. 49)
Astacopsis gouldi
Status: EN
Number of mature individuals: Approximately 100,000
Where in the world: Tasmania
Threats: This species prefers pristine waters so it is very vulnerable to logging, which has led to habitat loss and poor conditions. Though banned in 1998, poaching still continues to be a problem.

——

Axolotl (p. 51)
Ambystoma mexicanum
Status: CR
Number of mature individuals: Estimated less than 1,000
Where in the world: Mexico
Threats: Polluted waters, invasive species, and disease all threaten the axolotl's survival. Overhunting is also a problem; roasted axolotl is a delicacy in Mexico.

——

Agami heron (p. 53)
Agamia agami
Status: VU
Number of mature individuals: Unknown
Where in the world: Central and South America
Threats: Deforestation is the Agami heron's main threat as more and more land in the Amazon is cleared for cattle and agriculture. It is also thought to be affected by hunting.

——

Asian arowana (p. 55)
Scleropages formosus
Status: EN
Number of mature individuals: Unknown
Where in the world: Southeast Asia
Threats: Habitat loss is the Asian arowana's main threat. Illegal harvesting of the fish also takes place, with the most colourful specimens being particularly desirable.

Grasslands

Giant anteater (p. 59)
Myrmecophaga tridactyla
Status: VU
Number of mature individuals: Unknown
Where in the world: Central and South America
Threats: Giant anteaters are victims of habitat loss, particularly in Central America. They are also hunted as pests, for pets, or for illegal trade. In Brazil, many get caught in fires on sugarcane plantations, set ablaze prior to harvesting.

⸺

American burying beetle (p. 61)
Nicrophorus americanus
Status: CR
Number of mature individuals: Unknown
Where in the world: United States
Threats: No one really knows for certain yet what has caused this beetle's decline. But it is thought that habitat loss, human light pollution, and pesticides may all play a role.

⸺

Komodo dragon (p. 63)
Varanus komodoensis
Status: VU
Number of individuals: Approximately 3,000
Where in the world: Indonesia
Threats: It is thought that habitat loss due to human activity, poaching, and a loss of prey species are all to blame for the dragon's dwindling population.

⸺

Chinese pangolin (p. 65)
Manis pentadactyla
Status: CR
Number of mature individuals: Unknown
Where in the world: Asia
Threats: The biggest threat to the Chinese pangolin is hunting and poaching for the illegal wildlife trade. In China, their meat is considered a delicacy and their scales are used in traditional medicine there as well as in Vietnam.

⸺

Giraffe (p. 67)
Giraffa camelopardalis
Status: VU
Number of mature individuals: 68,293
Where in the world: Africa
Threats: The biggest threats to giraffes are habitat loss and large areas of their habitat being broken up, known as fragmentation. Illegal hunting, human-wildlife conflict, and ecological changes, such as drought, are also very real dangers.

Mountains

Saola (p. 71)
Pseudoryx nghetinhensis
Status: CR
Number of individuals: Estimated less than 750
Where in the world: Laos, Vietnam
Threats: The saola's major threat is hunting, or rather, being killed accidentally by the snares, guns, and dogs used for hunting other species. Its habitat is being destroyed and there is also the possibility that so few exist, many will be isolated from one another for breeding.

⸺

South Island takahē (p. 73)
Porphyrio hochstetteri
Status: EN
Number of mature individuals: 280
Where in the world: New Zealand
Threats: The takahē faces numerous threats including a decline in habitat quality, harsh winters, inbreeding, competition with red deer for food, and predation by introduced predators, such as the stoat.

⸺

Olm (p. 75)
Proteus anguinus
Status: VU
Number of mature individuals: Unknown
Where in the world: Europe
Threats: The olm is highly dependent on clean water and is very vulnerable to pollution, such as pesticides and sewage that are washed underground from the surface above. Some are also illegally caught for the pet trade.

⸺

Ili pika (p. 77)
Ochotona iliensis
Status: EN
Number of mature individuals:
Estimated less than 1,000
Where in the world: China
Threats: Competition with livestock for suitable grazing is a threat for the Ili pika. Climate change is also believed to play a role—as the Earth continues to warm, the pika retreat further up the mountain, seeking the cold temperatures they are adapted to.

⸺

Nilgiri tahr (p. 79)
Nilgiritragus hylocrius
Status: EN
Number of mature individuals: 1,800–2,000
Where in the world: India
Threats: Nilgiri tahrs have seen much of their habitat disappear, replaced with plantations for tea, coffee, and exotic trees. Illegal hunting and competition with livestock for suitable grazing make matters even worse.

Tundra

Snowy owl (p. 83)
Bubo scandiacus
Status: VU
Number of mature individuals: 28,000
Where in the world: Canada, China, Japan, Kazakhstan, eastern and Central Asian Russia, United States, Europe (Sweden, United Kingdom, Saint Pierre and Miquelon, Faroe Islands, Finland, Greenland, Iceland, Latvia, Norway, Russia)
Threats: Climate change threatens the snowy owl's survival, as changing temperatures affect both its habitat and prey. Electrocution from power lines, airplane strikes, getting tangled in fishing nets, and collisions with vehicles are also dangers.

⸺

Spoon-billed sandpiper (p. 85)
Calidris pygmaea
Status: CR
Number of mature individuals: 240–456
Where in the world: Asia
Threats: Habitat destruction and pollution both play a major role in the decline of the spoon-billed sandpiper. Hunting is a threat, with the birds often caught in nets intended for other species. Climate change is also expected to have a negative impact on the bird's breeding grounds.

⸺

Caribou (p. 87)
Rangifer tarandus
Status: VU
Number of mature individuals: 2,890,400
Where in the world: Canada, United States, Finland, Greenland, Mongolia, Norway, Russian Federation
Threats: For caribou, climate change is a very real threat. Rising temperatures in the Arctic are affecting snow and rainfall, with disastrous results. They are also vulnerable to unregulated hunting and habitat loss.

⸺

Suckley cuckoo bumble bee (p. 89)
Bombus suckleyi
Status: CR
Number of mature individuals: Unknown
Where in the world: Canada, United States
Threats: Pesticides, habitat loss, climate change, and air pollution are having a terrible effect on bee populations worldwide, and the Suckley cuckoo bumblebee's hosts are in trouble. If the hosts no longer survive, neither do they.

Wetlands

Fishing cat (p. 93)
Prionailurus viverrinus
Status: VU
Number of mature individuals: Unknown
Where in the world: South and Southeast Asia
Threats: Habitat loss is the fishing cat's biggest threat as wetlands across Asia are destroyed and converted into shrimp farms and rice paddies. They are also hunted for food, medicine, and body parts in some areas and human-wildlife conflict is a danger when cats are targeted to stop them stealing small livestock.

⸺

Pygmy raccoon (p. 95)
Procyon pygmaeus
Status: CR
Number of mature individuals: 192
Where in the world: Mexico (Cozumel Island)
Threats: Habitat loss is proving disastrous for the pygmy raccoon. Only a very small area of prime habitat exists—the very same area also targeted for tourist development. Non-native predators such as dogs and boa constrictors are a threat, as are inbreeding and injuries or deaths caused by cars and hurricanes.

⸺

Ivory-billed woodpecker (p. 97)
Picus principalis
Status: CR
Number of mature individuals: 1–49
Where in the world: United States, Cuba
Threats: Habitat destruction along with hunting, years ago, are responsible for the ivory-billed woodpecker's dramatic decline. Logging and clearing land for farming continue to pose a very real threat to any remaining population that may still be out there.

⸺

Pygmy three-toed sloth (p. 99)
Bradypus pygmaeus
Status: CR
Number of mature individuals:
Estimated less than 100
Where in the world: Panama
Threats: The main threat to the pygmy three-toed sloth is habitat destruction, which is shrinking its already tiny island home. And although it is uninhabited, seasonal visitors to the island are thought to hunt the sloth illegally.

⸺

Shoebill (p. 101)
Balaeniceps rex
Status: VU
Number of mature individuals: 3,300–5,300
Where in the world: Africa
Threats: There are many threats to the survival of the shoebill. Hunting and capture for the bird trade are increasing, while agriculture, fire, drought, and pollution all damage their habitat, and cattle have been known to trample nests.